W9-AKA-496

A Greek church in white and blue

Religious architecture constitutes perfect subject matter for beautiful paintings and compositions. Given the great variety of architectural styles throughout history, there are many sources of inspiration within this theme.

Cool spectrum

The dominant chromatic range is a crucial factor in the outcome of a finished painting. A painting is not always composed of a great variety of colors; sometimes its beauty lies in the harmony of tones, even if they are very similar to one another. In this case, cool colors prevail, mainly blues. Blue is the coolest of colors in the color spectrum because it doesn't have any warm tones. Greens and violets also belong in this category, although they are formed by blue mixed with some warm color tones. In this scene there are white and gray tones that define the base of the dome and the belfry. These tones help to reinforce the cool aspect, since they are neutral, and far from warm tones such as red, yellow, and orange.

Geometrical forms

The level of difficulty of a representation is related to the complexity of its forms. When you draw a building, for example, straight lines define its structure. Some styles, like Gothic or Art Nouveau, include many curved lines and ornaments that make the task more challenging. In this exercise, the structure has very clear and simple forms. The belfry is composed of straight lines and simple arches. The dome is simplified as a semicircle. An object's mass is portrayed differently in each geometrical structure. In the sphere, there is a gradation of color and light, while in the angular figures, mass is achieved by giving different tones to each plane.

Brushes

Fine round-tip brush

Medium round-tip brush

Medium flat-tip brush

Palette colors

Cadmium Orange	Ultramarine Blue	Burnt Sienna
Cerulean Blue	Sepia	Ivory Black
Cobalt Blue		

Painting the background

1

Once the drawing is well defined, begin to apply the color. Avoid going over the drawing's lines, so that the silhouette of the building is accurately depicted. Use special care when outlining the crosses, since they are small and set elements in the drawing. Outline these forms very slowly, preventing water from entering their space. Make sure the inner space remains dry.

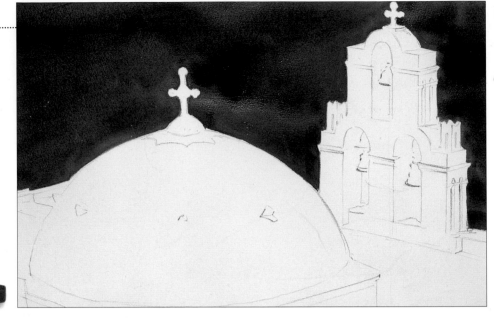

Ultramarine Blue Ivory Black

The color of the stone

2

Now, color the white stone of the building. Pure white should only be in those areas where the sun hits directly. The areas that do not receive direct sunlight will appear darker. Avoid using diluted black to achieve the right hue of gray for those areas, since it results in a very artificial tone of gray. Rather mix complementary tones to obtain more integrated, neutral colors.

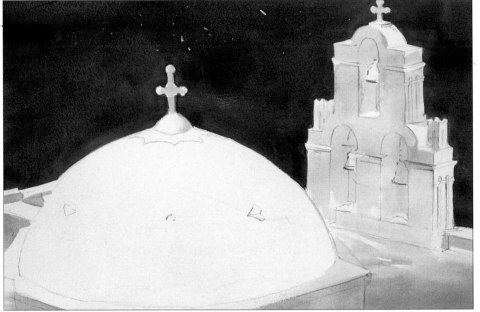

Cobalt Blue Burnt Siena

Cadmium Orange

Painting the dome

3

Here again is a large area to fill with color and it's the purest color in the whole painting. Mix two extremely luminous shades of blue. The appearance of mass will be achieved by a gradation of color, applying more pigment in the lower part of the dome, and more water on the upper part. The result… the color will appear brighter and more transparent.

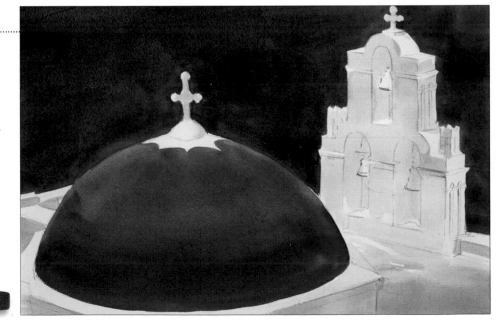

Cobalt Blue Cerulean Blue

Cadmium Orange Ivory Black

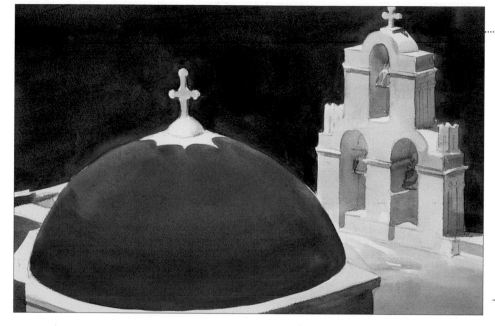

Establishing contrasts

4

Emphasize the dimensions of the stone by darkening the shaded sides. To do that, mix black and orange, which results in a neutral color that is dark enough to combine perfectly with the rest of the grays. Then paint the lines carefully to ensure they look straight.

Ivory Black Ultramarine Blue

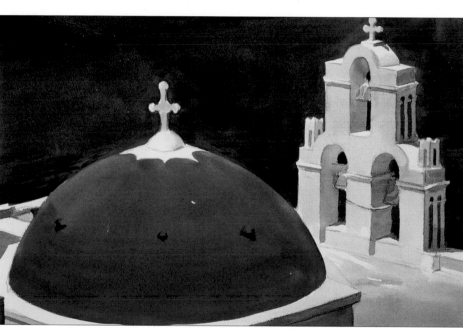

Defining details

5

Once the general colors have been applied, define the smaller details. The darker small spaces in the dome are painted using a thin, round-tip brush. The same brush is also used to define the side arches of the belfry, and the empty spaces of the frontal arches through which the background is seen.

Sepia Cadmium Orange

Sepia

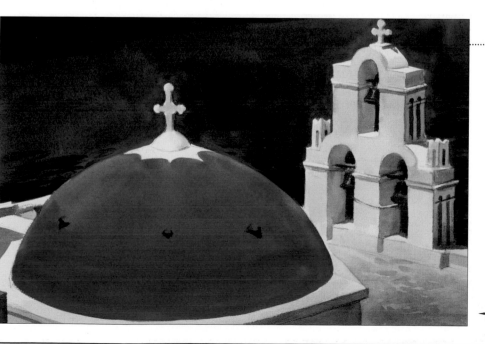

The final result

6

Once the last areas on the belfry are dry, begin the finishing touches of the painting — coloring the bells. Use a dark color, a mixture of orange and sepia, and apply it with a thin round-tip brush. Leave a space of light color in the center to reflect the light on the metal. To conclude, touch up the contour of the bells.

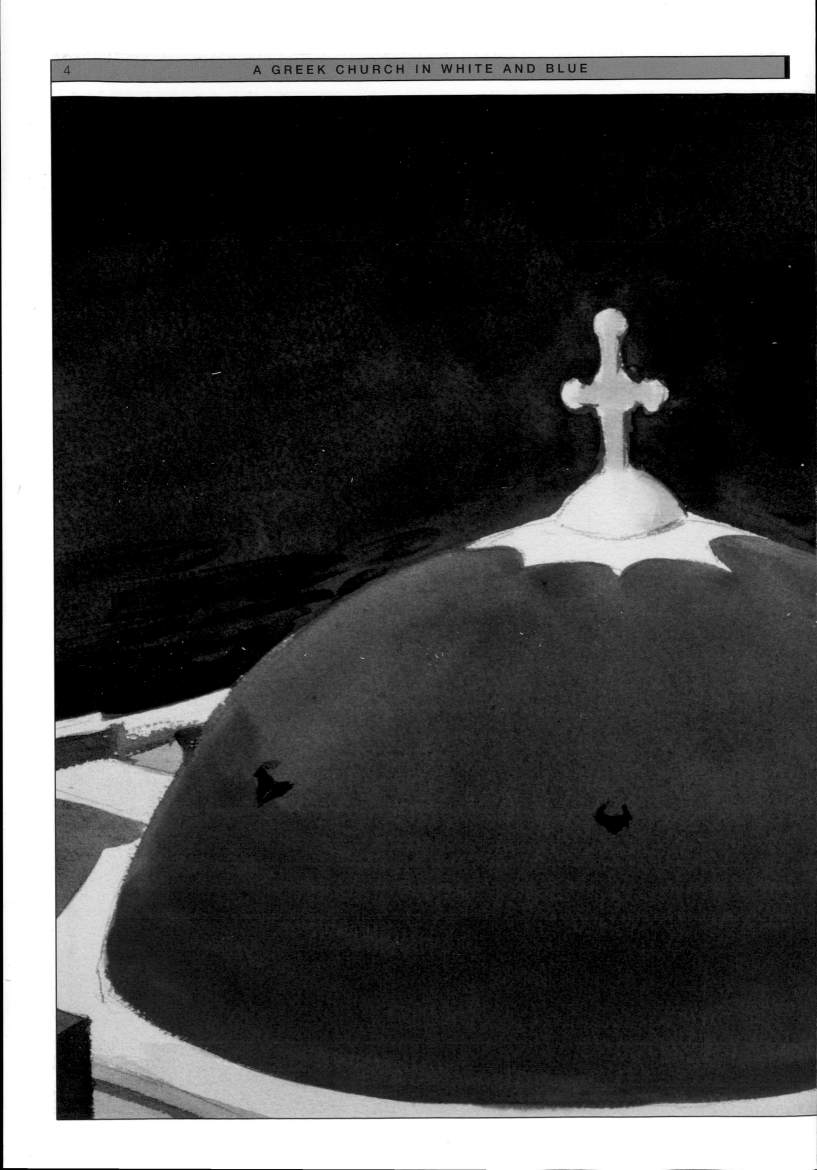

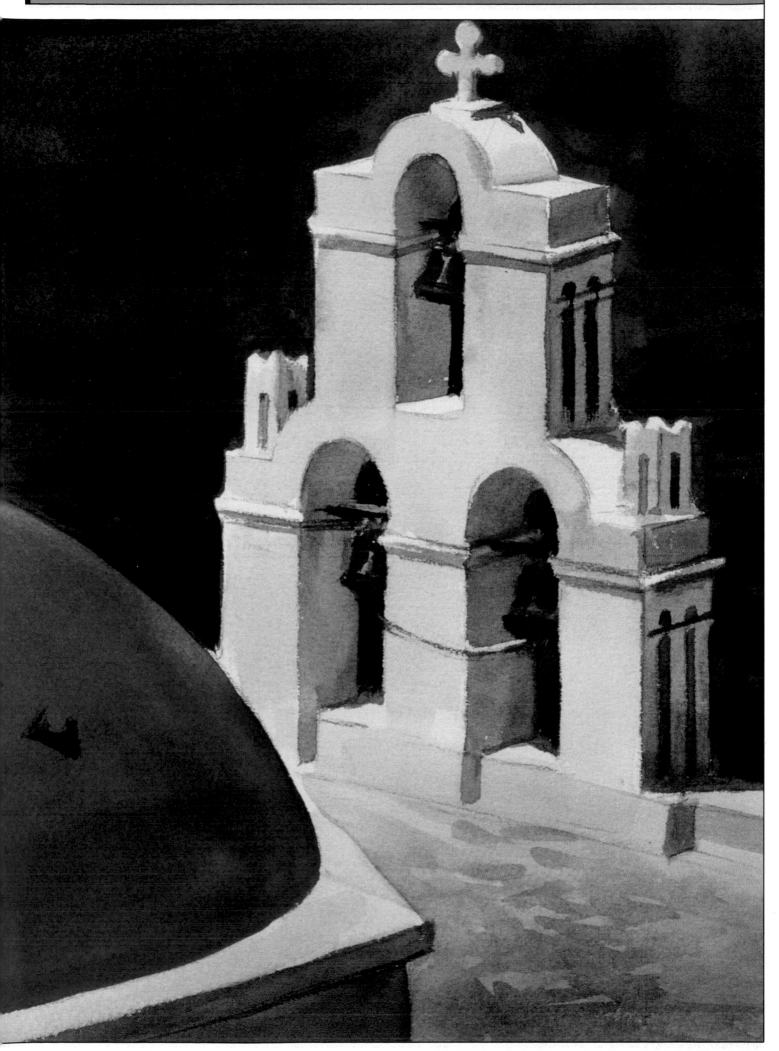

Suggestion for framing

Consider a wide frame and double matting. For the inner matting that frames the work, choose one that is thin and white to add light. For the second matt, choose a neutral gray. Given that the painting is a composition of blues, white and grays, warm-color matting offers too much contrast, and it would disrupt the ensemble's harmony. Gray is a color that combines with any other color, especially with cool colors like blue and violet. Finally, choose a gray frame with aged texture, similar to the tone of the stone in the painting.

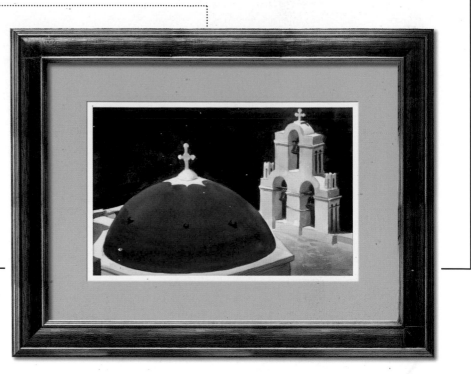

ADVICE

It is important not to mark up the drawing too much, since the lines will show through the watercolor, especially in clear colors. We recommend using a soft graphite pencil and press very lightly when drawing.

Composition of watercolor paper

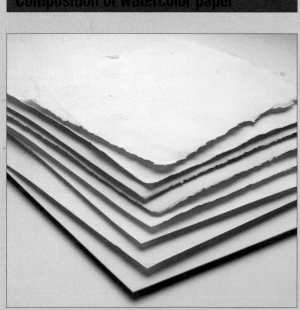

Watercolor paper is composed of several materials, especially wood paste, glue and cotton. Cotton determines the paper's absorption. Quality paper usually has 50% cotton fiber that quickly absorbs moisture. The rest of the elements determine the paper's rigidity and quality: the glue and the wood paste maintain the paper's stability after many layers of painting. In general, a good paper is rigid and compact, and has enough cotton fiber to absorb all the liquid that is applied.

Stretching the paper

Watercolor paper generally has to be stretched before use. This is especially true with lighter weights of paper, which will otherwise buckle after absorbing water. You can paint directly onto paper without stretching it, but it would be better to try this using a heavy paper that can absorb a large amount of water without wrinkling.

Wet the paper in a receptacle with water or under the faucet.

To best control the amount of water, use a sponge.

After wetting and stretching the paper, allow it to completely dry before painting to prevent it from rippling. Affix the paper with adhesive tape.

Two flowers on a blue background

Flowers represent one of the most popular themes for beginning painters. With practice, they can be drawn alone or combined with other household objects to create a more complex and interesting still life.

Brushes

Fine round-tip brush

Medium round-tip brush

Medium flat-tip brush

Palette colors

Cadmium Yellow	Permanent Crimson	Sap Green
Cadmium Orange	Cerulean Blue	Hooker's Green
Cadmium Red	Cobalt Blue	

Plain backgrounds

When one or several objects are represented, all of their characteristics depend entirely on the surroundings. The background enhances the color of the forms in the foreground. A cluttered background diminishes the importance of the foreground, and can make the composition and the distance between objects confusing. Plain backgrounds are ideal to enhance and frame the main forms of the painting, since they don't distract attention. Rather, they allow you to clearly see all of the characteristics very realistically. For this type of background, recommend using a thick, flat-tip brush, proportional to the painting's size. With the space in and around the object, use a finer brush to portray the contour in a precise manner.

Pure colors

Flowers are natural elements of great chromatic variety and purity. In fact, many of the brightest and most spectacular pigments are derived from chemically treating a flower's petals. A determining factor in emphasizing a color's power is lighting. Direct light, whether artificial or natural, demands color be applied directly from the tube, especially with very bright colors. Primary colors such as red, yellow, and blue cannot be obtained by mixing with other tones. Thus, apply them directly. The other colors are obtained by mixing the above-mentioned ones. The greens, oranges, and violets are pure colors, although they can be obtained from the mixture of primary colors.

The blue background

1

Start by painting the background and reserving in white, the area for the flowers, stems and leaves. The stems are very thin, so control the brush to prevent paint from entering these small areas. To achieve uniform color across the background, use the medium flat tip brush soaked in paint. Apply the paint until all the areas have the same intensity.

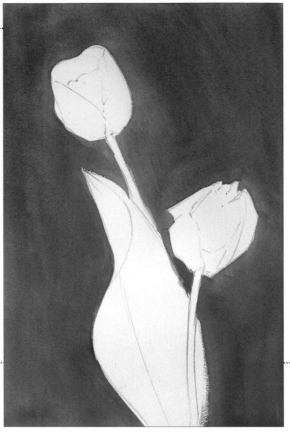

Cobalt Blue Cerulean Blue

The flower's base colors

2

Keep the paint application flat, avoiding any build up of volume. The intention is to fill areas of color and cover the white of the paper. The flower on the right is painted with a very diluted yellow, enhancing a natural light feeling. Conversely, the red flower receives more pigment so that it looks very intense, more so than the background.

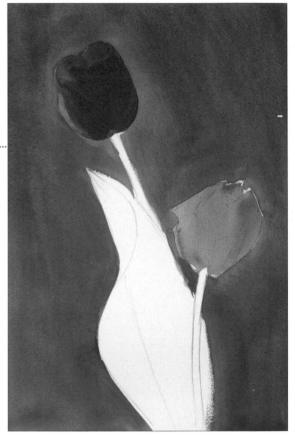

Cadmium Red Cadmium Yellow

The green tones

3

Although the leaf and stems have different tones of green, start by establishing a bright and defined base that can be darkened if necessary. Try not to overlap the line of the drawing, as the color of the background will change if the color comes in contact with the blue.

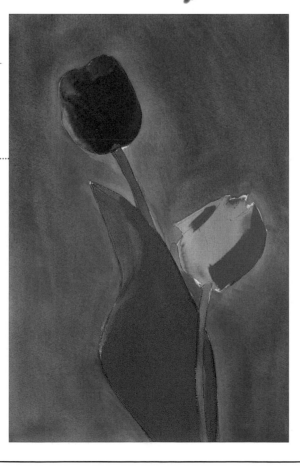

Sap Green Cadmium Yellow

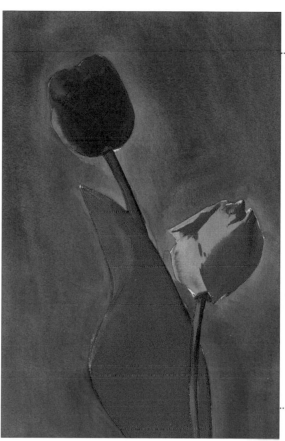

Cadmium
Yellow

Cadmium
Orange

Sap Green

ADVICE

Beginning a painting with the background helps to contrast all the elements: brightness, shading, and color intensity. All of the colors used to paint the flowers are in direct relationship to the basic reference established by the background.

Defining the petals

4

First, make sure that the base color is dry, so that in defining the set forms the pigment does not dilute with water. The bright flower on the right allows denser yellows and oranges to define the petals and give it body. The stems are defined by darkening their sides, leaving a bright zone in the center. Accomplish this by using a fine round-tip brush.

Sap
Green

Hooker's
Green

Cadmium Red

Looking for the mid-tones

5

Work now begins on the green tones over a colored base. This base corresponds to the brighter areas of the leaf, particularly where it folds. Darken the shadowed side of the leaf with a shade of more intense color. As a result, you gain a differentiation of planes, producing the first sense of dimension.

Cadmium
Orange

Permanent
Crimson

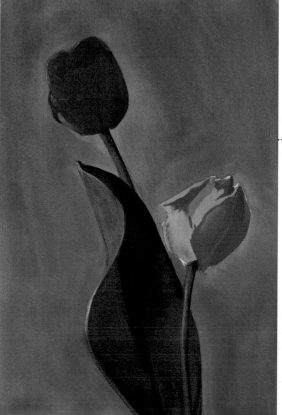

The final contrast

6

Once the leaf is darkened, the contrast is totally defined. Darken the green using a tint of a reddish tone, its opposite. The stem on the right is complete with its brightness maintained. Before touching up thin forms, be sure the previous color is dry.

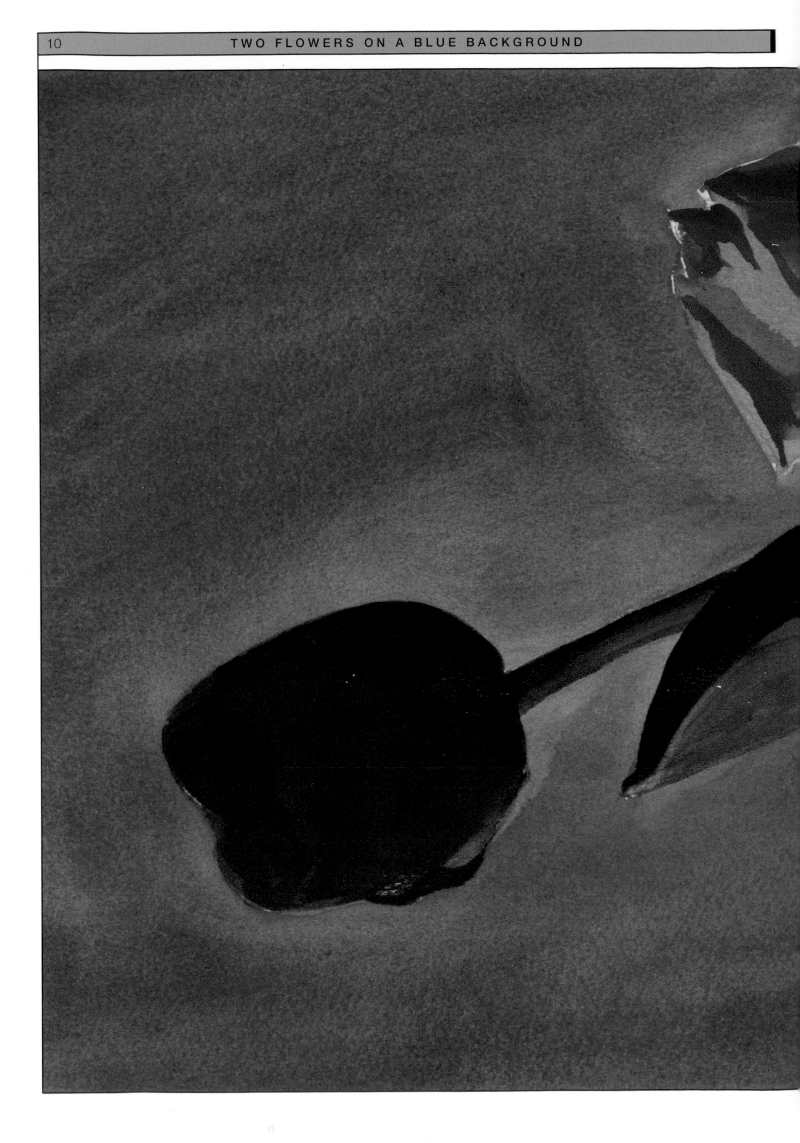

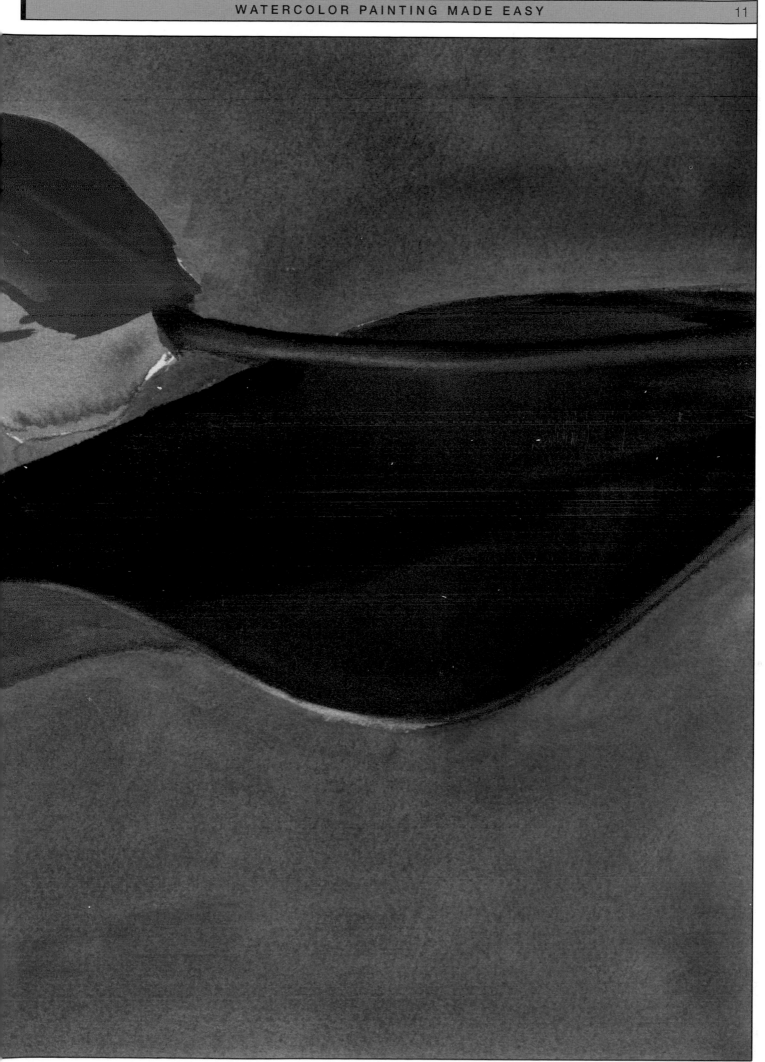

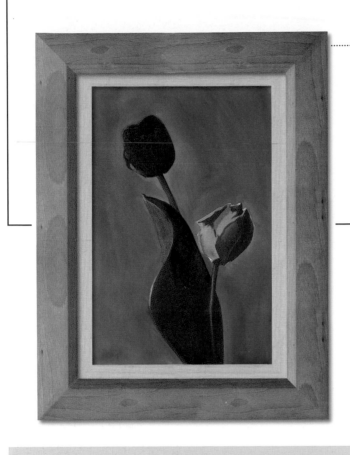

Suggestion for framing

Choose a simple frame since basic colors and simple forms dominate the painting. With a simple frame, the painting remains the primary focus. Here the frame is composed of two pieces, the first one confines the painting, and the second one completes the ensemble. The two pieces are a smooth wood. The exterior piece is darker than the interior one, which has a soft, clear, almost white color. A lighter frame is chosen so that the darker and more intense watercolor is the feature despite its simplicity.

ADVICE

When doing a gradation of color, never paint backwards with the brush. Otherwise, the upper part of the painting becomes lighter, ruining the desired effect.

How to prepare a color for painting

When painting a watercolor, colors are diluted in water to be applied in a liquid form. If many tones are used, dilute the previous color then apply onto the paper. To cover a large area, for example a background, it's best to dissolve color separately in a small bowl.

From a tube

1. Squeeze a small amount of color in the bowl.

2. Add clean water with the brush and mix it thoroughly.

From a paint pan

1. Wet the paint pan with a soaked brush.

2. Move the paint to the bowl as many times as needed until the right amount and intensity of color is achieved.

How to dry the brush

If your brush is wet with watercolor, remove it in clean water and dry it with a clean cloth — always use a clean cloth. The cloth can also be useful to absorb excess moisture from the brush. Completing this task, the brush is ready for use.

When too much color is applied on the paper and you want to lower the intensity of a tone, correct it in the following way: First, apply clean water, which will mix with the paint, diluting the tone. Second, apply a dry brush on the wet area, to absorb the excess of liquid reducing the intensity of the color.

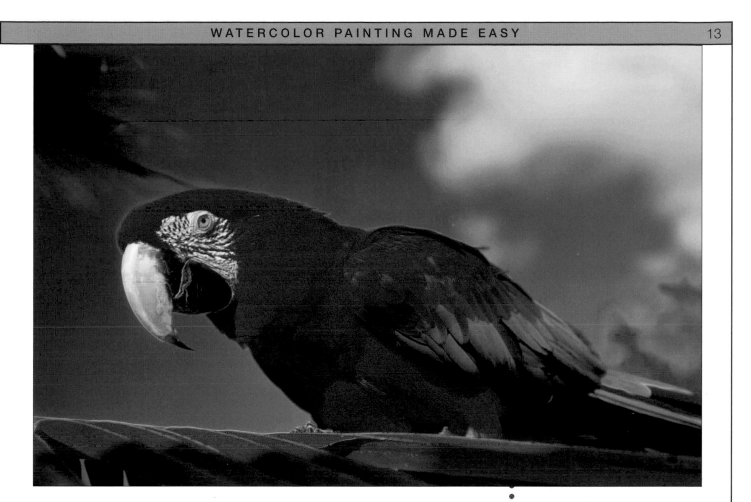

Exotic parrot

Of all the animal species on earth, some birds show a plumage of spectacular color, similar to flowers or coral. Exotic, tropical birds, whose chromatic characteristics are vivid and dramatic, represent attractive subject matter for any artist.

Contrasting colors

A contrast is established when two very different colors are linked. There are two basic types of contrast. The first one is defined by light: a bright color next to a dark one generates a strong contrast. The second one is defined by chromatic complements, that is, by putting together two opposite colors. Here, for example, the parrot's plumage is composed of very bright reds and greens. At its basic level, green is the only secondary color not formed with red (magenta); that's why it is its opposite. Other secondary colors are violet and orange. Violet is formed with magenta and blue, and its opposite is yellow. Orange is formed with yellow and magenta, and its opposite is blue.

Moisture and brushstrokes

In general, watercolor is a very agile and spontaneous medium. Its beauty lies in the instantaneous mix of colors, with blending occurring as they come in contact with each other. Control of water and dryness are the factors that will determine the finished painting. They are difficult to control for a novice painter. Any well defined brushstroke or thin line has to be done with dry paint. Using a thin brush is not enough, for the brushstroke will mix and diffuse with the other colors if the paper is not dry. Use a hairdryer to speed up the drying of the paint. Otherwise, you will have to wait for the paint to dry before working on details and set lines.

Brushes

Fine round-tip brush

Medium round-tip brush

Thick round-tip brush

Wide flat brush

Palette colors

Lemon Yellow

Cadmium Yellow

Permanent Crimson

Hooker's Green

Cadmium Orange

Cerulean Blue

Burnt Sienna

Cadmium Red

Cobalt Blue

Ivory Black

Sky and clouds

1

Begin by painting the background blue, but not the entire surface. In the areas on the right, gradually dilute the paint with water to the white of the paper reserved for the clouds. Next, begin to work on the palm tree branches to the left, as well as those under the bird, using a medium round-tip brush.

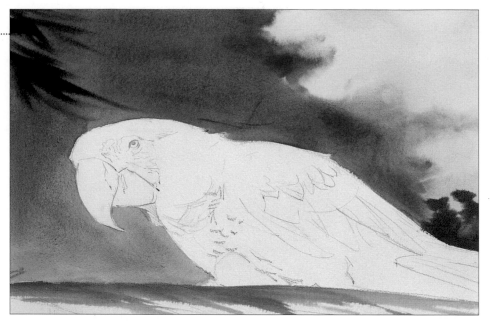

Cobalt Blue Cerulean Blue

Lemon Yellow

Hooker's Green Cadmium Yellow

Painting the parrot's body

2

Once the background is dry, color the head and the chest of the parrot with cadmium red. At this stage, establish an even color with a lot of pigment, carefully rendering the silhouette of the animal. Use green and yellow to work on the palm tree branches.

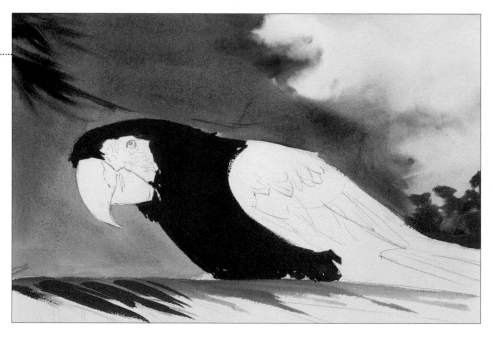

Cadmium Red

Painting the wing

3

The plumage of the parrot has a variety of red, green and blue tones. These are small areas of color that cannot be painted in the same way as the parrot's body. The upper part is painted red, with small brushstrokes imitating the feathers. Work on the green area in the same way. The lower part of the tail is painted blue.

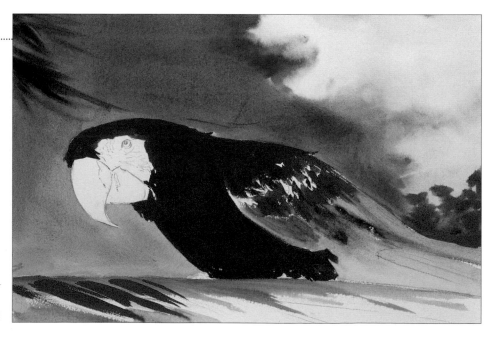

Hooker's Green Cerulean Blue

Cadmium Red Permanent Crimson

Hooker's Green Cobalt Blue

Lemon Yellow Cadmium Orange

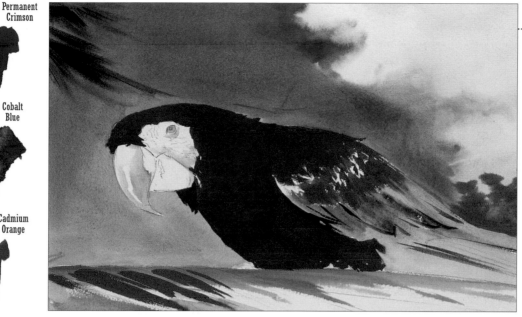

Creating definition

④

Once the base paint has dried, incorporate the details. Define the feathers on the parrot's red body with darker brushstrokes. The darker red tone will also be useful to darken the lower part of the body, giving it depth. Define the wider feathers of the wing by applying thin and long strokes in green and blue. In addition, paint the beak with a clear, neutral color.

Ivory Black

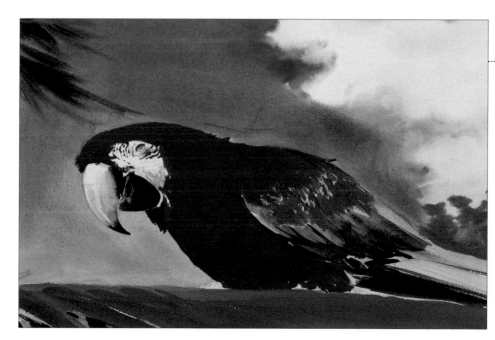

Adding darker colors

⑤

More contrast is still required. Add a very dark blue on the lower part of the tail, which makes the lighter feathers stand out. Using green, paint the palm tree branch that holds the parrot. Add black to the beak, both on its tip and around the mouth. A thin line must be drawn to separate the upper and lower part of the beak.

Permanent Crimson Burnt Sienna

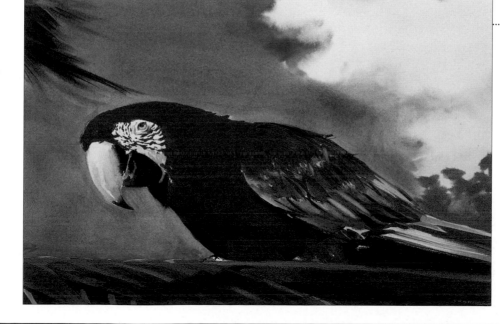

The final details

⑥

Now, add the last dark tones to the lower part of the wing, the chest, and the palm tree. The bright colors will stand out by contrast. Draw the parrot's eye, as well as the little red feathers around it. For these final details use a very thin brush.

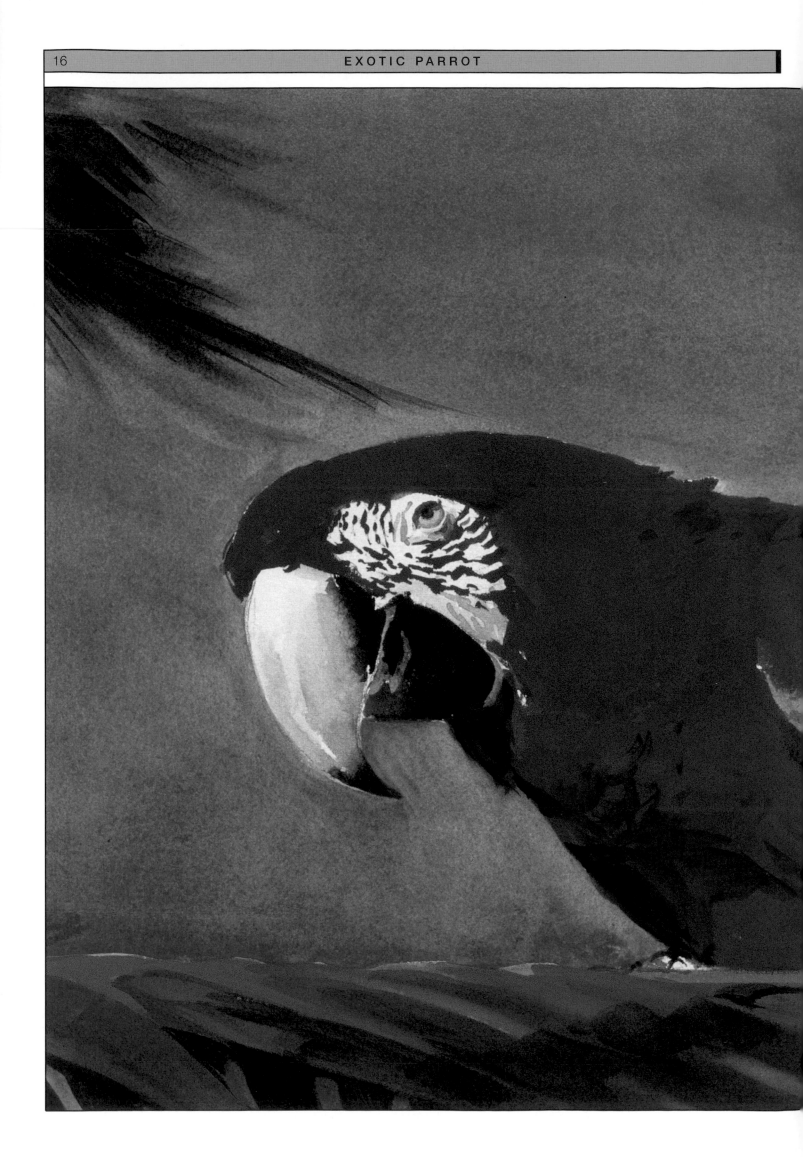

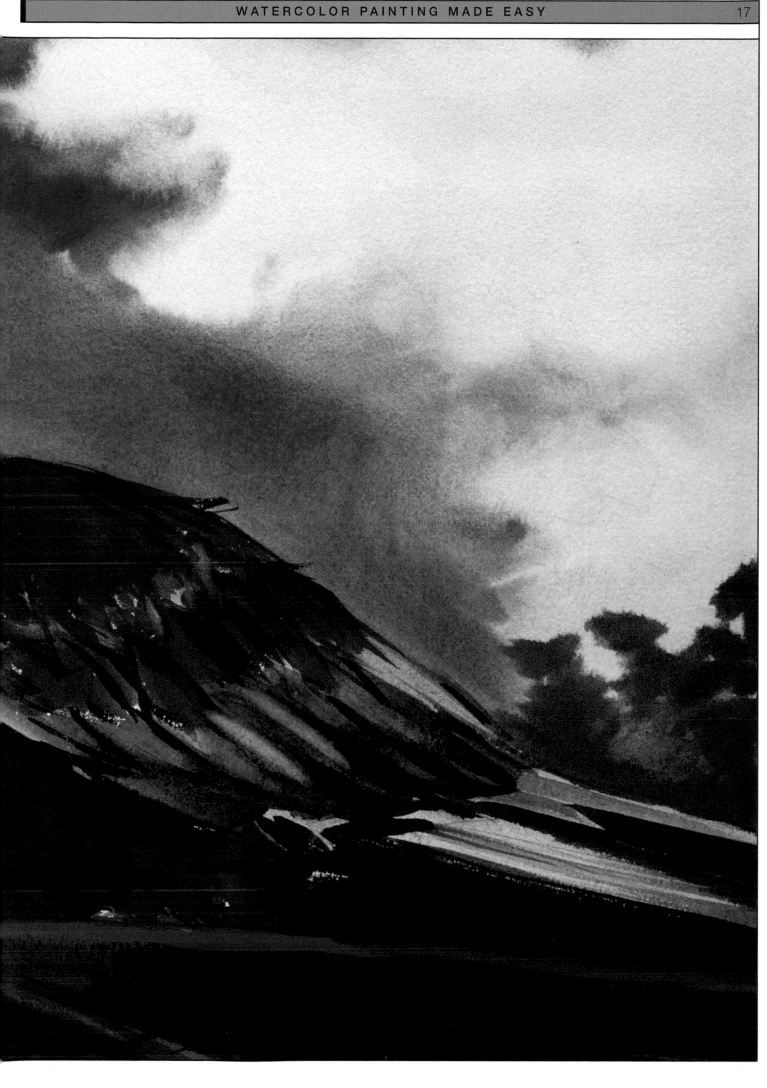

Suggestion for framing

The subject is very intense featuring varied color; the painting is very strong in color and the tones are vivid. The frame should complement these colors without diminishing their importance. Recommend off-white double matting, that clearly distinguishes the watercolor from the frame, making the painting appear wider. The frame is an intense reddish-brown wood frame, high-lighting the colors of the parrot. Thus, the frame relates to the reds of the parrot's body, while it complements the greens and blues of the wings and the trees.

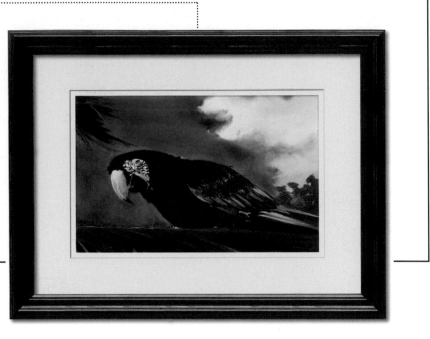

ADVICE

Types of watercolors

Watercolor paint in pans are a commonly used format. They are easy to transport, since they usually come in small boxes and you only need to include a water container and a piece of cloth.

Tube watercolors represent the professional approach. Their pigments are very pure and they have greater capacity for color than pans. To use them, you need a palette with clearly differentiated areas on which to place the liquid color once dissolved. If you don't use all of color, it can be reused by adding water after it has dried.

Liquid watercolors are the least convenient. They can be used to paint a large surface, in a way similar to India ink, in monochromatic studies, or in a simpler watercolor wash.

Watercolors can come in three different types of containers: pans, tubes, and liquid watercolors.

The grain of the paper

There are different types of watercolor paper, depending on the grain. The basic ones are: fine-grained, medium and course-grained.

Glossy paper is not very convenient for watercolor, for it does not absorb water. Since the liquid creates puddles, the paper easily curls.

Fine grain allows for neat strokes and well-delineated profiles. Its absorption capacity, however, is rather limited.

Medium grain is the ideal for watercolor painting. It absorbs the pigment well and without puddles, and allows for hard and precise lines.

Course grain is perfect to work with a lot of water. However, its rough surface complicates the creation of precise lines and shapes.

Composition with apples and leaves

A beautiful still life composed of very simple objects: a basket with some green apples and fall leaves, in red and orange tones.

The still life as a theme

A still life composition is good subject matter for beginning painters. Using an actual model, rather than a photograph is desirable as it is the best form to stimulate your artistic sense. A still life is composed of inert objects that can be chosen at will — it can be a few objects of simple shapes. This is a challenge for the beginning watercolorist, as it requires patience and attention to represent the colors correctly, addressing dimension, the shadows projected from one object to another, among other considerations. Showing light in a still life is not problematic, since it can be controlled by the artist. For example, the artist can use fixed artificial light and avoid natural light, which is always changing.

Light and shadow

Unless the object is flat, the light and the shadow on its surface visually determines the object's mass. Ultimately, the mass of a subject is expressed by means of changes in the light tones. Round or curved objects are painted by gradating the pigment. The brightest area will be lighter and, little by little, objects can darken until they reach an area that receives the least amount of light. Working with watercolor here, white is not used since light and darkness are conveyed by a greater amount of water or pigment. In this still life the contrasts are very strong, as the contact between objects create sharp shadows. To accentuate these shadows, the application of added pigment is not enough. Rather it's the addition of the appropriate color: a sepia tone is ideal to enhance the shadow of any other tone.

Brushes

Fine round-tip brush

Medium round-tip brush

Thick round-tip brush

Medium flat-tip brush

Wide flat brush

Palette colors

Cadmium Yellow	Cadmium Red	Burnt Sienna
Cadmium Orange	Sap Green	Sepia
Yellow Ochre	Hooker's Green	

Yellow as the base

1

Here the scene is mostly based on warm colors, as every color has yellow as part of its composition. To unify the general tone of the painting, paint the entire area of the paper with a shade of very light yellow. In the area of the leaves, increase the intensity of the color.

Cadmium
Yellow

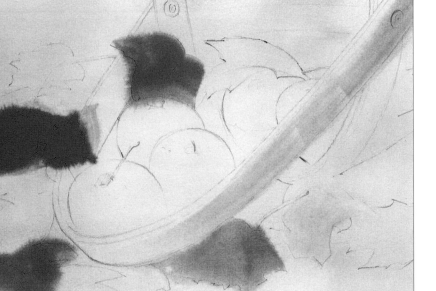

Coloring the apples

2

First, give a soft green color to some leaves, either by painting them in their entirety, or by applying small brushstrokes. The apple is painted with more density of pigment, leaving a clear color on the upper part of the leaves, and adding more pigment on the lower part. The two apples in the basket are also painted with green, but do not establish any contrast for the moment.

Sap Cadmium
Green Yellow

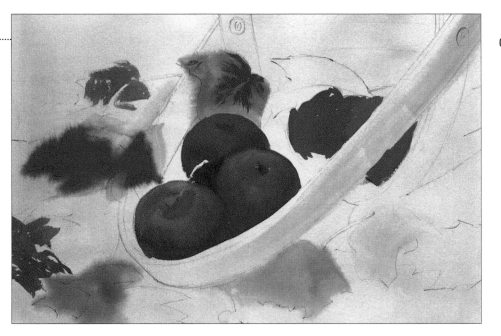

The brown basket

3

Begin by painting the basket in a brownish tone. The basket occupies ample space and is very important for the composition. Do not paint the basket in one tone. The inner part and the handle are darker; therefore, apply more pigment to these areas than on the external side. The light shade given to the latter enhances the brightness.

Sap Yellow
Green Ochre

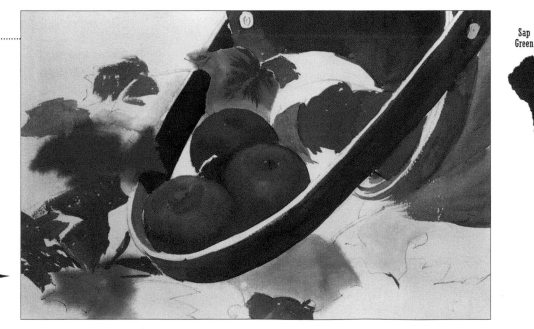

Cadmium Red · Sap Green

Cadmium Red · Burnt Sienna

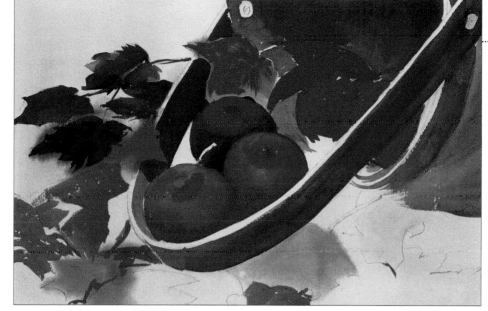

Defining the leaves

4

Define the leaves in the background with intense tones, rendering their clear shapes so they appear well-defined. Use darker greens, reds and oranges. Establish contrast in one of the apples with an intensity that is in harmony with the intensity of the leaves.

Sepia

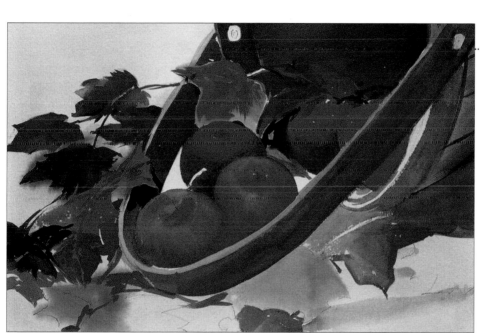

Contrasts

5

Now add pure sepia to establish the highest contrast in the whole scene. This color will be used in the shadows projected by the apples on the basket. Sepia also gives more intensity to the inner part of the basket, so that the sense of depth is enhanced.

Hooker's Green · Cadmium Orange

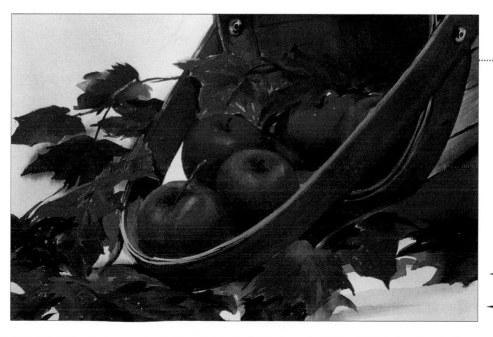

Finishing the foreground

6

To conclude, darken the lower part of the apples and basket. Using a thin brush, draw the details of the basket, such as its curve lines, screws, etc. Add color to the leaves in the foreground, with tones in the spectrum of reds, greens and ochre. The shadow of the leaves on the ground is achieved with a soft shade of sepia.

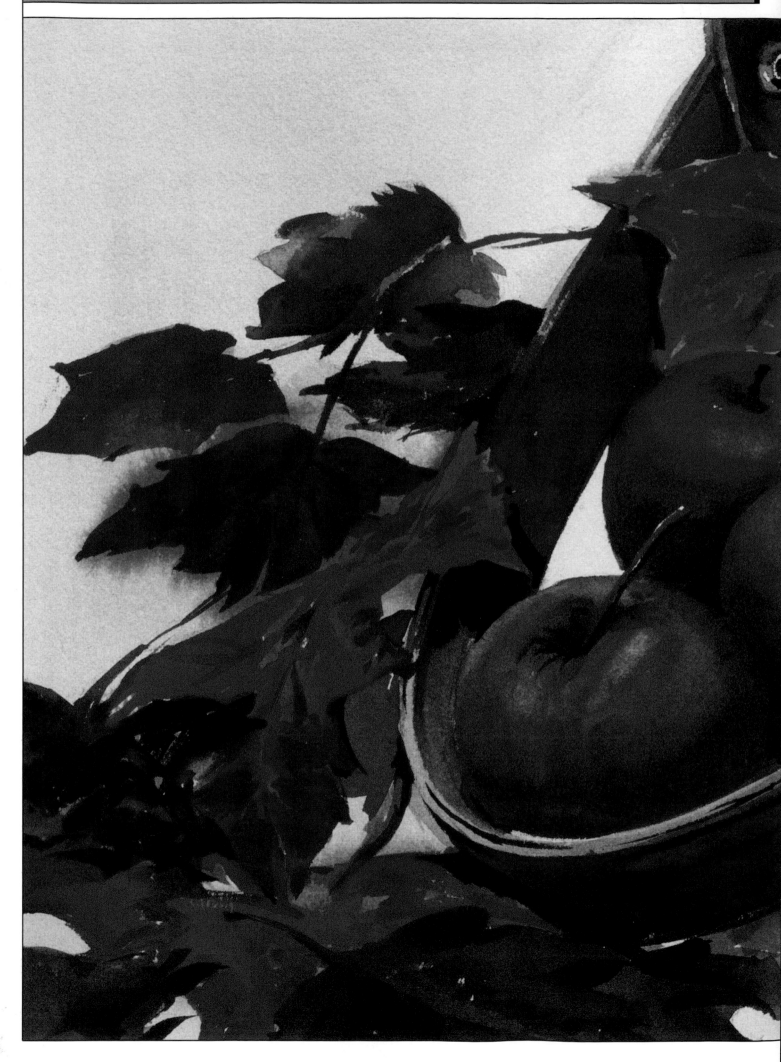

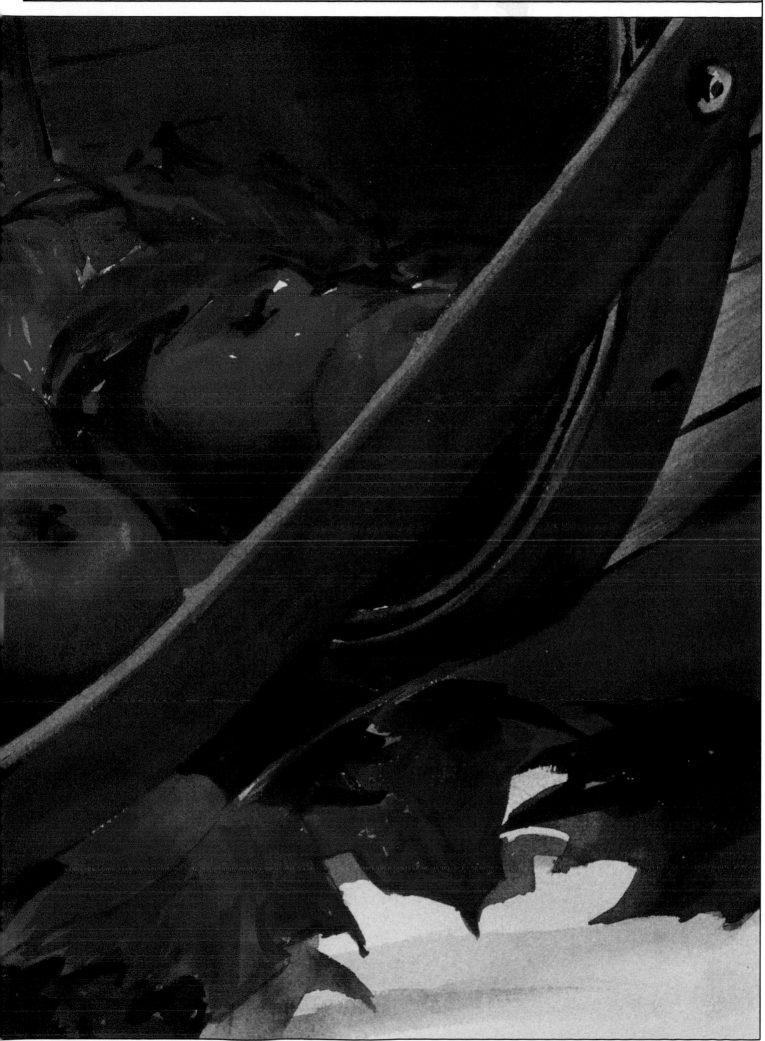

Suggestion for framing

This still life is a very classical style, so build on that theme. The painting has certain complexity, considering all its elements, and offers many contrasts and details. When a drawing is complex, the matting plays a very important role in separating the drawing from the frame. Recommend double, cream-color matting that harmonizes with the browns, greens and reds in the painting. The frame is a classic profile, an aged copper-like color that adapts itself to the drawing's notable qualities.

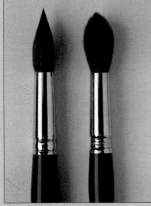

ADVICE

Brush characteristics

To paint effectively with watercolors, look for soft and flexible brushes. The ideal brush is one made of sable hair, but oxen hair and synthetic brushes can also be used. Avoid pig's hair brushes since its rigidity does not retain liquid paint making outlines difficult, and it may even damage the paper.

Tonal scales

Tonal scales are achieved by changing the intensity of a color from saturation to transparency.

The variation in tone on wet paper is a gradation. Intense color is applied on one end of the paper and is then diluted with water until the whiteness of the paper is eventually reached. Always work from dark to light.

When the paper is dry, the variation in tone is achieved with different layers of color. This is accomplished by applying one darker shade on top of a lighter one until the desired intensity of color is reached.

Cloudy sky landscape

Wet watercolor allows for the beautiful gradation of colors, especially when painting the sky. Use this technique to accurately paint clouds with a light and airy quality.

Painting outdoors

The great masters of 19th Century art began to leave their studios for the out-doors. Their interest was centered on the beauty of nature, on natural light, the sky, water, and the land. Until that time, art was mostly practiced in the studio, with still life, nude models and portraits as main themes. The communion with nature represented a new pictorial interest: the experimentation with light and color over the traditional forms associated with drawing. Landscapes offer, more than any other subject matter, an endless array of colors and compositions. This painting genre offers a wide range of pictorial expression that is freer and more diverse than studio painting.

Gradating a color

The creation of a correct gradation depends on using the right brush. Wide and medium brushes are good for broad, uniform grada-tions, and they are ideal for backgrounds. Use other brushes to work on gradations of smaller areas, and on a variety of specific gradations like clouds in the sky. Watercolor is perhaps the best technique for grada-tions, since it does not require the use of white. Here, brightness comes from the paper itself. It's simply a matter of adding water without having to use any other color. Another way to work with gradations is by taking pigment off. When the paint is still wet, lower its intensity by applying a dry brush to absorb the excess moisture and pigment.

Brushes

Fine round-tip brush

Thick round-tip brush

Narrow flat-tip brush

Meduim flat-tip brush

Palette colors

Cadmium Yellow	Cerulean Blue	Sepia
Cadmium Orange	Cobalt Blue	Burnt Sienna
Yellow Ochre	Hooker's Green	Ivory Black

The first brushstrokes

1

Begin to work with brush-strokes of cerulean blue mixed with cobalt blue. Use a lot of pigment and water to fill the space uniformly, so the brushstrokes are not noticeable. Achieve different color intensities by applying more or less water. To do this, use a thick round-tip brush, appropriate for large surfaces.

Cobalt Blue Cerulean Blue

Continuing with the sponge

2

Use the sponge to soak up the excess pigment and make sure to avoid the reserved white areas. The white space is going to be the area for the largest and most important cloud on the upper right side. The sponge is the perfect tool to convey light and airy effects.

The first cloud shapes

3

You have already established the upper part of the clouds, forming soft, gentle shapes. The proportionate amount of water causes the pigment to diffuse from top to bottom. In the central part of the clouds, a gray tone is introduced to achieve the effect of mass. In the upper cloud, the color mixes softly with the moisture of the paper. For the lower, smaller clouds, use small brush-strokes.

Cobalt Blue Burnt Sienna

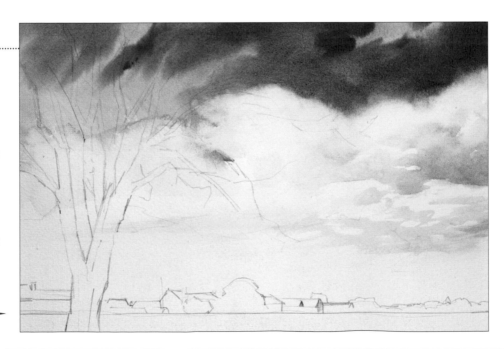

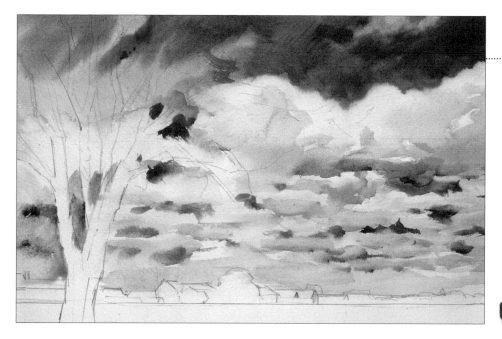

Completing the clouds

4

Continue defining the clouds all the way to the horizon line. This is a quick and intuitive process. Since you are working on a wet surface, different brush strokes will mix with one another, creating a delicate appearance of the sky. In general, the lower part is composed of small, gray clouds. Between the clouds apply blue brushstrokes to define the spaces where the sky is visible.

Hooker's Green Sepia

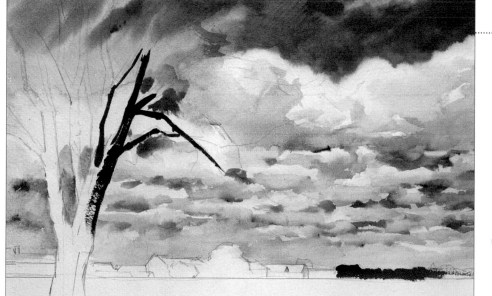

Incorporating dark colors

5

Now begin to paint the tree and the distant greenery. First, wait for the sky to dry completely. The resulting brushstrokes are well defined and will not mix with the previous ones. The color is a mix of sepia and green, resulting in a dark tone that contrasts well with the brightness of the sky.

Cadmium Yellow Hooker's Green

Cadmium Yellow

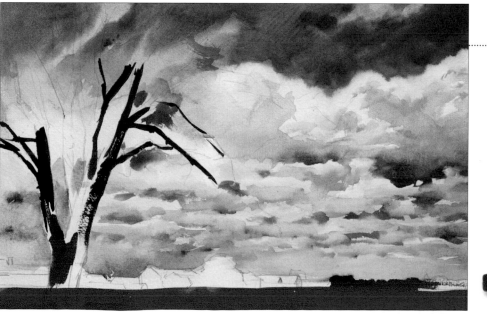

Starting the flat land

6

Continue filling up spaces. On the trunk and branches of the main tree add some greenish tones. Then paint the entire field in the lower part of the painting using yellow with horizontal strokes. Next, beginning at the base of the tree, paint some light green brushstrokes.

Defining the composition

7

Begin by defining the details in the horizon. Paint the roofs of some houses in ochre tones, and use sepia and black for the large tree in the background. In the foreground, continue painting the secondary branches of the main tree, especially those on the right.

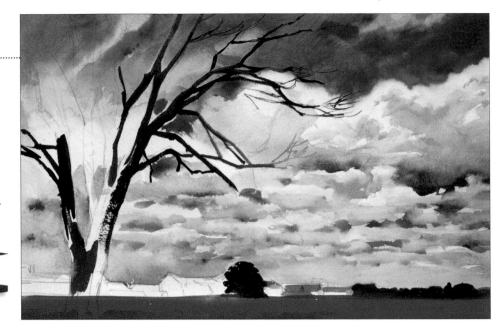

Yellow Ochre

Ivory Black Sepia

Defining the tree

8

Now combine new tones on the tree trunk. Use the same color as before, but this time, add more water. As a result, a lighter tone is produced for the brighter part of the trunk, accentuating its mass and shape. Continue painting the roofs with sienna and green, and the house walls with gray tones.

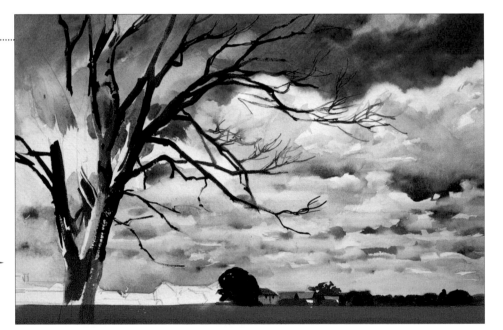

Burnt Sienna

Burnt Sienna Hooker's Green

The base of the tree

9

Continue painting the trunk all the way to its base. Alternate between warmer colors and the brown and green previously used. Around the base of the tree, apply some green brushstrokes, imitating the color and profile of grass. In addition, paint all the upper branches. Then go to the background to paint the roofs on the left.

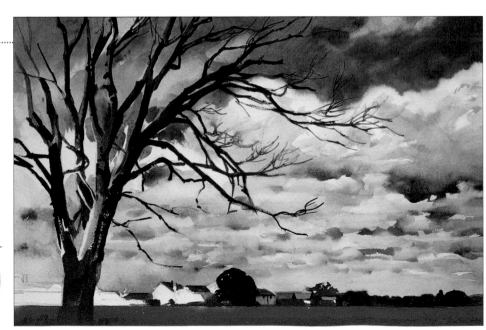

Burnt Sienna Sepia

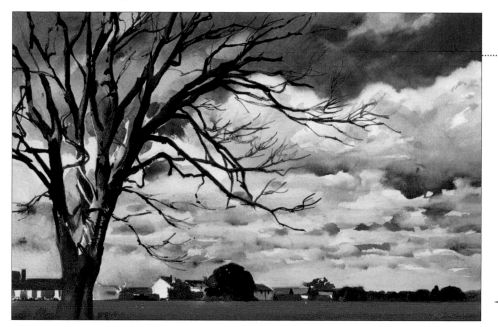

Completing the background

10

Paint the rest of the houses and trees in the background. Since they are very small elements, use a fine round-tip brush, using green and sepia for the trees, and earthy tones for the houses. Some white walls should be left unpainted. In the foreground, continue drawing secondary branches. On the lower part of the trunk, apply two vertical shadows to further emphasize its stature.

Cadmium Yellow Sepia

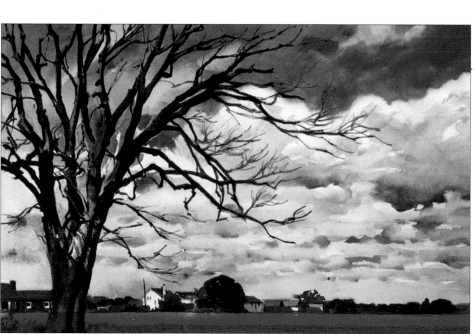

Foreground details

11

Continue to define the details of the houses, such as windows, doors, etc. Darken some areas that are in the shade, and the houses behind other houses. The remaining trees should be painted in a dark green. In the foreground, make sure the detail at the base of the trunk, and the grass around it is correctly portrayed.

Hooker's Green Cobalt Blue

Cadmium Orange

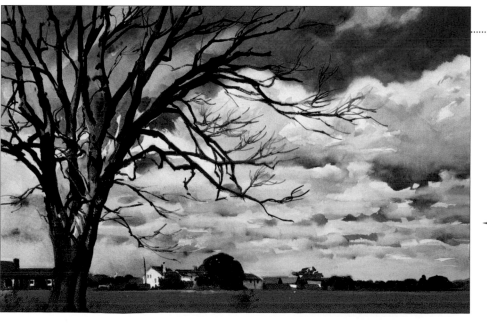

Final touches

12

When the paint is completely dry, work on the final details in the foreground. Add bushes on the lower part of the composition. On the yellow field, incorporate some orange and greenish tones to indicate the areas where the grass should be taller.

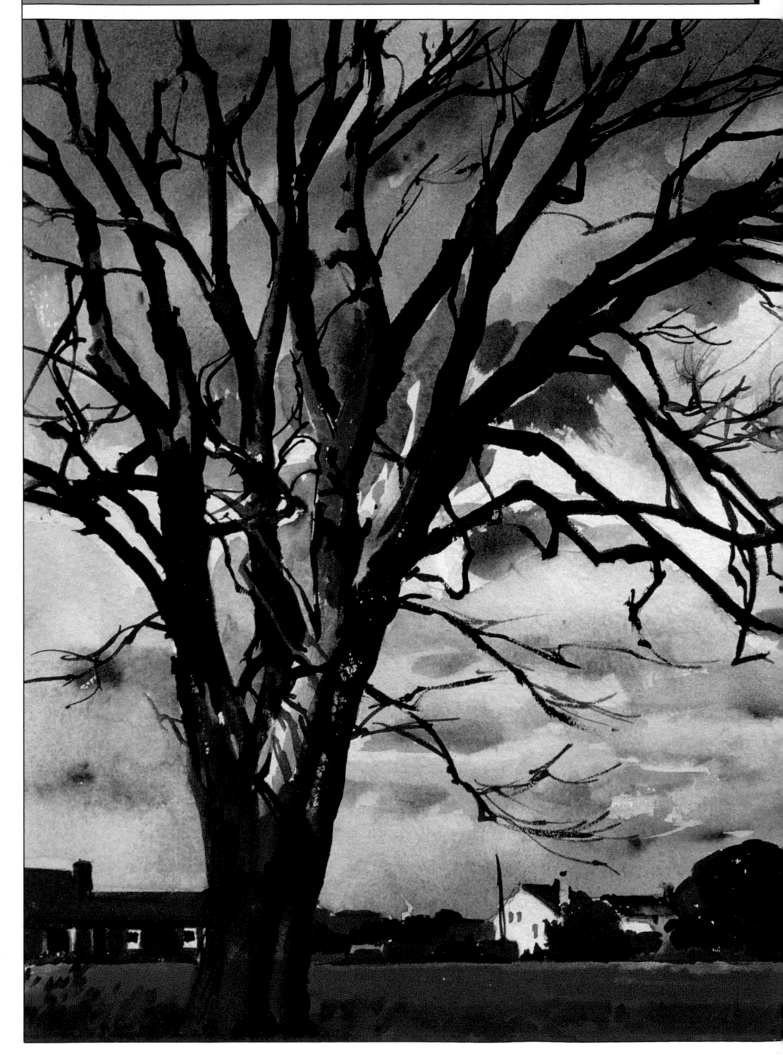

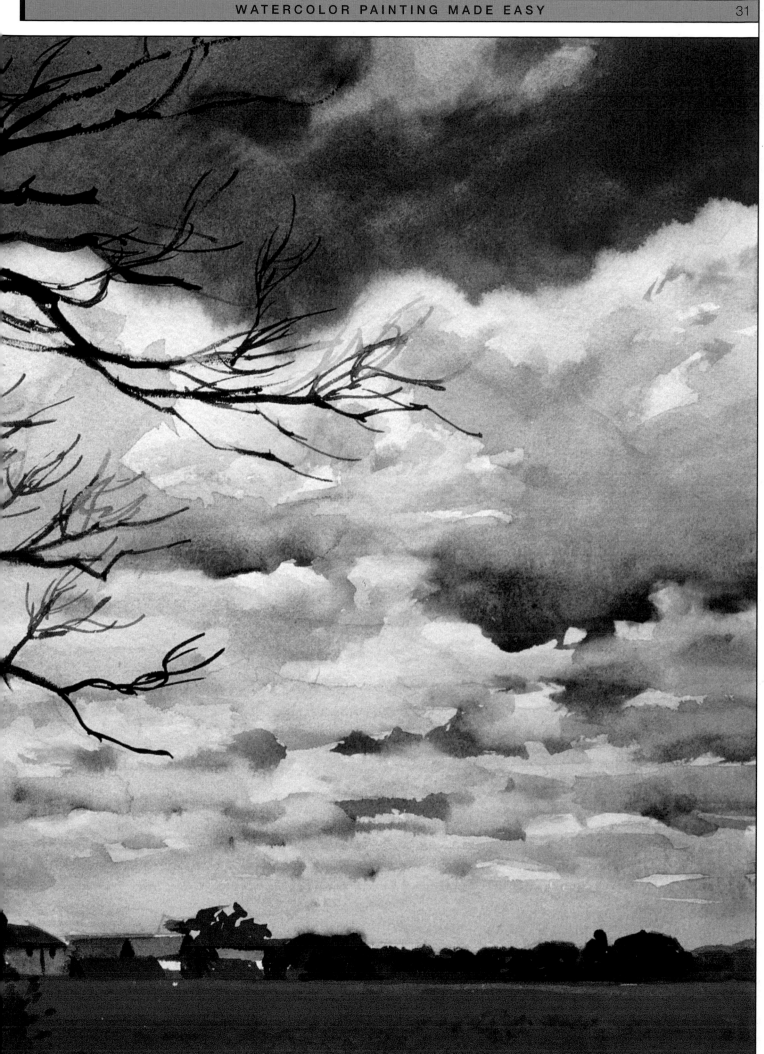

Suggestion for framing

In this landscape dominated by the sky, there is a predominance of blue and white tones. Recommend a grayish frame that complements the picture's cool colors. Complete the framing with an off white, double matting, that reflects the painting's neutral and soft tones. The wooden frame completes the framing. Select a light wood frame of a color similar to the clouds. The important consideration, as always, is to find framing that enhances and presents the qualities of the painting.

ADVICE

You don't need to paint all the elements at the same time. Paint the background first, that is, the sky, the field, and the houses. Then, when everything is dry, paint the tree and the branches.

Types of palettes

Watercolor palettes are made of materials repellent to water, such as metal, plastic, or ceramic, the latter is the most refined and expensive. There are also "palette boxes", in addition to the most conventional, oval-shaped or round palettes, with a hole for a finger to hold it. The key feature is the presence of cavities to hold the liquid paint. Flat palettes are good for dense pigment, but watercolor typically flows over their surface. As an option, you can make a receptacle using plastic egg containers, or a plate.

Pallete box with lid.

Round metallic palette.

Conventional plastic palette.

Use of the sponge

Sponges are very useful tools for watercolor painting. They are used to apply color, to eliminate the excess of color, as well as to wet the paper and prepare it for use. Here it is used to eliminate moisture and lower the color intensity. When the pigment is very intense, and more transparency is needed, soak the sponge in water and apply it to the color which will immediately dissolve. Then squeeze out the moisture and apply it again on the area, and the color becomes even lighter. Always use the sponge for large surfaces. Details and smaller areas should be treated with a brush.

Note how the color intensity has been lowered to reach pure white.

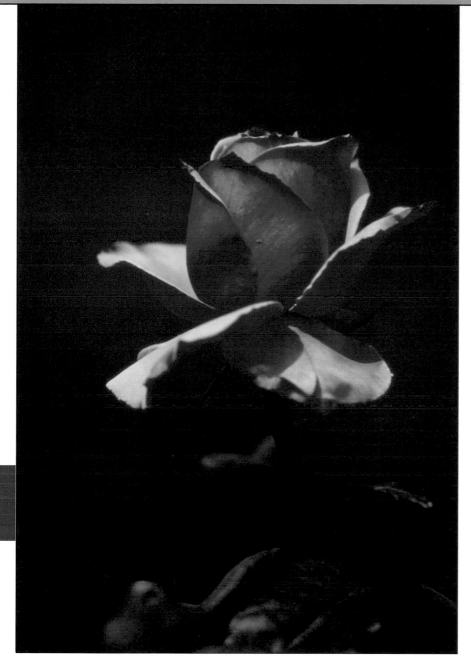

Rose on a smooth background

The rose is one of the most beautiful flowers in nature. It is also one of the most painted flowers by artists, due in part to the unusual shape of its petals, and the intricate way they open.

Brushes

Fine round-tip brush

Medium round-tip brush

Thick round-tip brush

Medium flat-tip brush

Palette colors

Magenta	Cobalt Blue	Olive Green
Cadmium Red	Prussian Blue	Sap Green
Permanent Crimson	Hooker's Green	Sepia

A painting with few colors

The chromatic spectrum of a subject depends on several factors. First, consider the number of elements to be represented. Obviously, the more varied the elements, the greater the use of color and textures. The artist's work also becomes more complex, the greater number of colors and gradations used. Another important factor is the number of light sources that affect the object. When there is only one light source, the gradations and tonal changes are simple. As different light sources are added, tonal qualities become more complex. When a composition has very few elements, it's simpler to perform: the number of colors is reduced, with the main difficulty being — creating contrasts with fewer tones. Precise drawing is very important here, as with a single object, mistakes are more obvious than in an ensemble.

Contrast

The contrast in a work is determined by the lighting of the objects. The effect of a direct light source is more dramatic than the effect of a soft and diffused one. Color contrasts determine the general tone of a work, and present a good representation of an object's mass. The correct contrast in a work is as important as the precision of the drawing. Both elements have to be well-balanced. The mass of the object is conveyed by the accurate distinction between the areas of light and shadow. Without this quality the object appears flat. In order to achieve the correct balance, study the details in the lightest tones, and proceed to establish the intermediate colors by gradation.

Filling in the background

1

Color the background using a mix of olive green and sepia. A dark and neutral tone is achieved that will enhance the lively colors of the flower. Use a thick round-tip brush. Be careful when outlining the edges of the flower, especially on the thinner stems — as these areas call for a medium round-tip brush.

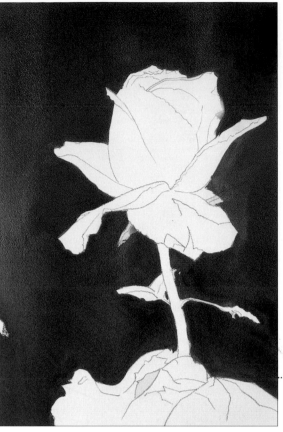

Sepia

Olive Green

Painting the flower

2

Crimson is the first color to be applied to the flower. To intensify the color under some of the petals, and in the central area, lighten it with water. The goal is to establish a soft color on which to apply more intense tones later.

Permanent Crimson

First contrasts

3

Intensify the colors of the flower by applying a mix of red and magenta to the inner petals. The result is a very intense tone that enriches and defines the petals. In the lower petal, continue adding very diluted crimson. Apply sepia to the stem with just a little water.

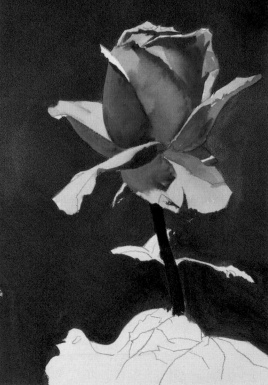

Cadmium Red

Magenta

Sepia

Hooker's Green

Sepia

Permanent
Crimson

Cobalt Blue

Hooker's
Green

Sepia

Sap
Green

Prussian
Blue

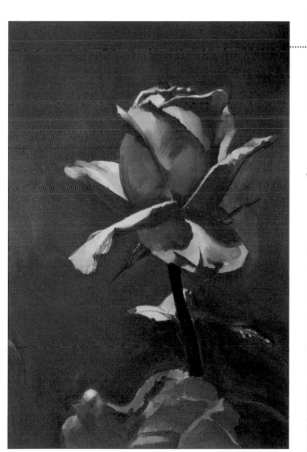

Hooker's
Green

Prussian
Blue

Prussian
Blue

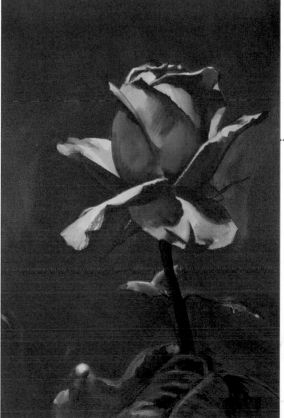

Reinforcing contrast

4

Keep working on the flower, applying colors that will reinforce the contrast. Using a thin round-tip brush to depict the shape of the petals with a mix of sepia and crimson. Then continue the gradating technique with crimson. In the lower part of the painting, establish the tone of the leaves with Hooker's green, applied flat for now.

Defining the leaves

5

To work on the leaves, divide the space in different colors. On the right, apply sap green. In the middle area, use a mix of Hooker's green and sap green. On the left, create a dark tone from a mix of sepia and prussian blue. In addition, work on the small leaves with cobalt blue, especially the ones on the left.

Final result

6

Create the final contrast in the leaves using a thin brush to render the established tones and shapes. Use prussian blue on the small leaf, and different strokes of prussian blue and Hooker's green on the big leaves.

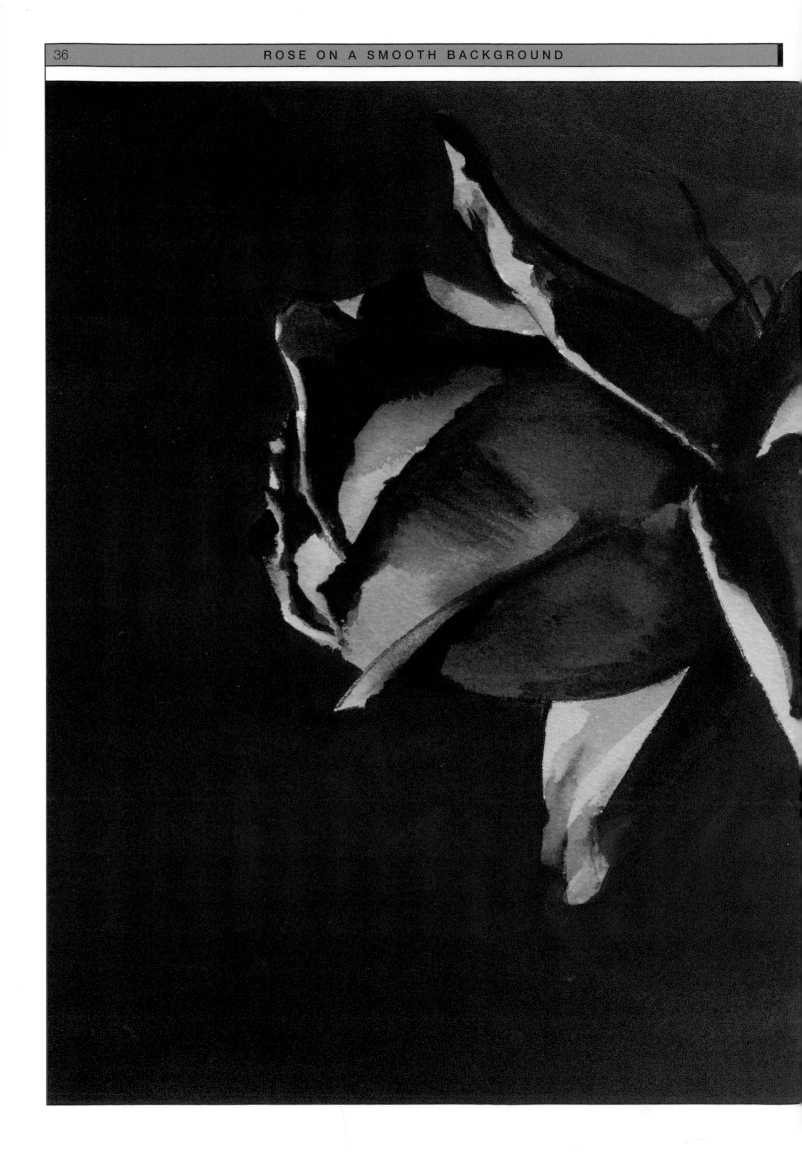

Suggestion for framing

For this painting consider a frame which is at the same time classic and romantic, in agreement with the theme since a rose is an element of serene beauty. Recommend a light frame with a golden and aged patina. Then use a double matting, thin and white on the inside, to contrast with the dark background of the painting. The external matt is wide, in an off-white tone, which will combine with the tones of the rose and the frame.

ADVICE

To maintain the defined tones of the interior petals, wait until the first pink gradation is completely dry before applying more paint.

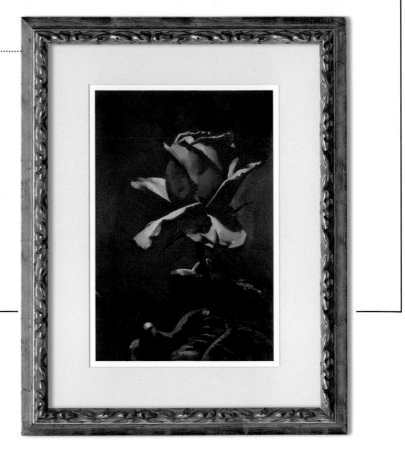

Thickness of the brush

The brush handles have a number that corresponds to its size. The sizes range from very thin, with very little hair (which are appropriate for linear and small details), to very thick ones, ideal to fill backgrounds. The thinner ones (number 0) are often used in illustration to draw lines with watercolors and gouache. They work like a sharpened pencil, or like a thin felt-tip pen. In general, there is not much use for extremely thin brushes in watercolor. Therefore, use a few round-tip brushes. Medium and thick round-tip brushes are often used in watercolor. Use these brushes to apply the main colors and fill the larger spaces.

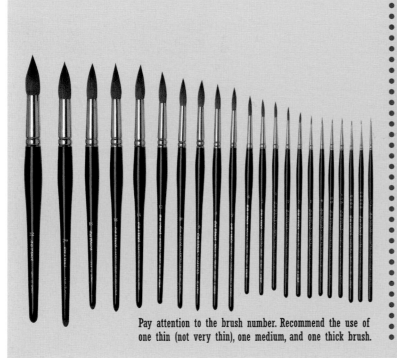

Pay attention to the brush number. Recommend the use of one thin (not very thin), one medium, and one thick brush.

Pencil line as the boundary

Watercolor requires a very precise base drawing. Corrections cannot be made by painting with white. You must be careful when applying color around the lines, especially when the colors on each side of the line are different.

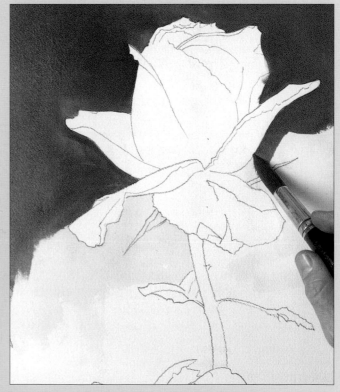

Observe how to render the outside silhouette of the rose with the brush, and not go over the pencil line.

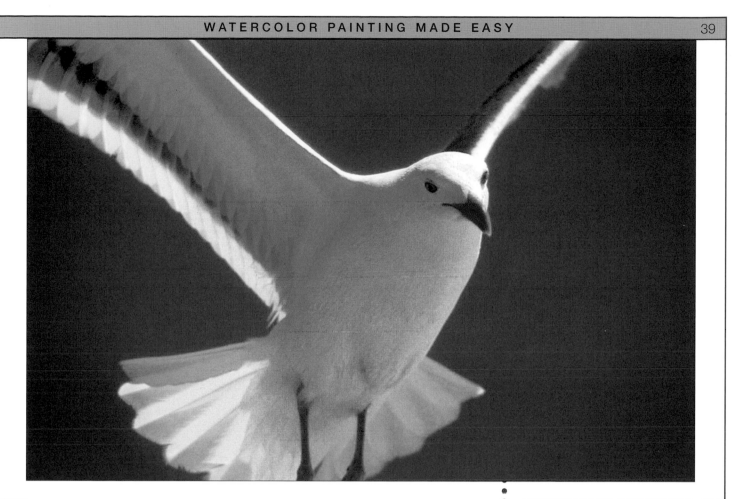

Flying Seagull

The flight of a bird is one of the most elegant movements seen in nature. It is also a graceful way to observe the beauty of a bird's plumage.

The composition

The composition of a work is ruled by the distribution of the elements appearing within its margins. When there is only one object, as in this case, the composition is determined by its position and angle. In the selection of this image, the decision was made to exclude part of the bird's wings. Given their size, if they had appeared in their entirety, details of the feathers or the head would have been lost. Another important aspect is the flying position. The v-shaped wings create a well-balanced composition and the play of diagonal lines are more attractive than horizontal lines. It is the artistic judgement of the painter or the photographer to capture a particular movement or position.

The gray palette

Gray is a neutral color, and when combined with other colors, especially with pure and bright tones, their intensity is accentuated. There are different ways of producing gray, primarily through the combination of black and white, or, in watercolor, with a diluted black. However, this is not the only way. Gray is also obtained by mixing complementary tones, especially blue and its opposites — reds and oranges. The gray that results from diluted black is cooler and "dirtier" than the color resulting from mixing blue with its opposite tones. The latter procedure also produces a variety of tones, from warm and reddish to cool and bluish, always within a neutral palette.

Brushes

Thin round-tip brush

Medium round-tip brush

Thick round-tip brush

Medium flat-tip brush

Wide flat-tip brush

Palette colors

Lemon Yellow Cobalt Blue Sepia

Cadmium Orange Ultramarine Blue Burnt Sienna

Cerulean Blue

The blue background

1 Fill in the background using the wide flat-tip brush, being very careful with the outer lines of the bird. To ensure a precise outline, the pencil lines have to be very clear. Add a lot of water to dilute the background colors, a mix of cerulean and cobalt blue. The goal is to achieve a smooth and transparent color.

Cerulean Blue Cobalt Blue

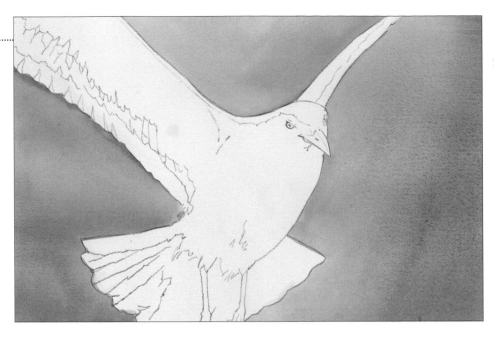

The first grays

2 Mix burnt sienna and cerulean blue to produce a neutral gray. Add a lot of water to gain transparency. You can always darken it later if necessary. For this stage, use a thick round-tip brush, being careful to paint the area in a uniform way.

Burnt Sienna Cerulean Blue

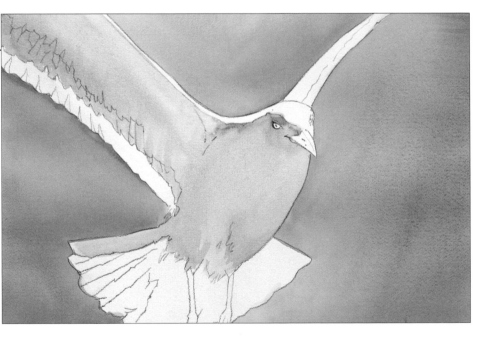

The light areas

3 Using a medium round-tip brush, establish the bright areas with a diluted lemon yellow. Use plenty of water to achieve a very pale yellow.

Lemon Yellow

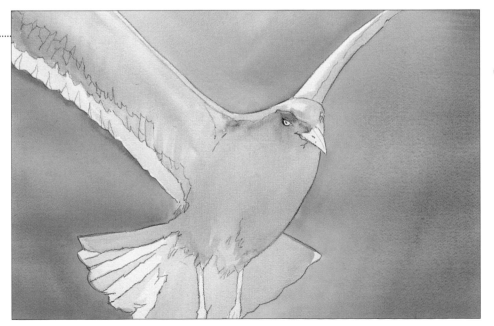

Lemon
Yellow

Cadmium
Orange

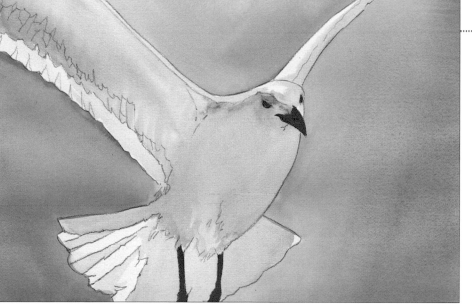

Coloring the small areas

4

Use a very warm color for the beak, the eyes, and the legs of the bird. Since these are very detailed elements, use a thin round-tip brush. A very intense color is required, so do not add much water. The color is created by mixing lemon yellow and orange.

Burnt
Sienna

Ultramarine
Blue

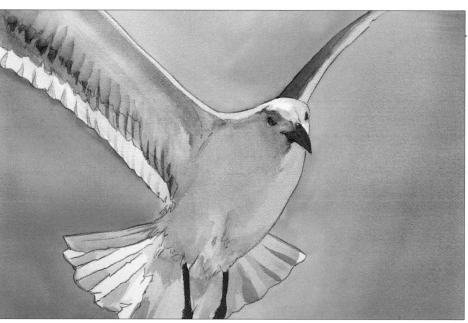

Intensifying the gray

5

Using a medium flat-tip brush, work on defining the form of seagull with dark grays. This time mix burnt sienna and ultramarine blue. To color the tail dilute the pigment resulting in a gray similar to the first one applied. Intensify the color of the wings for a more dramatic effect.

Sepia

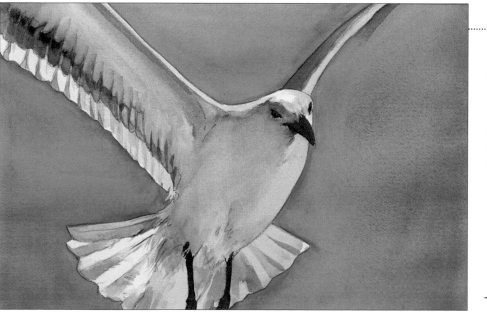

Final details

6

The final touches are created with very pronounced brushstrokes of sepia, using a fine round-tip brush. Add detail to the left wing by defining the feathers one by one. Accentuate the contour of the eyes, the beak, and the legs, so their shapes are well defined.

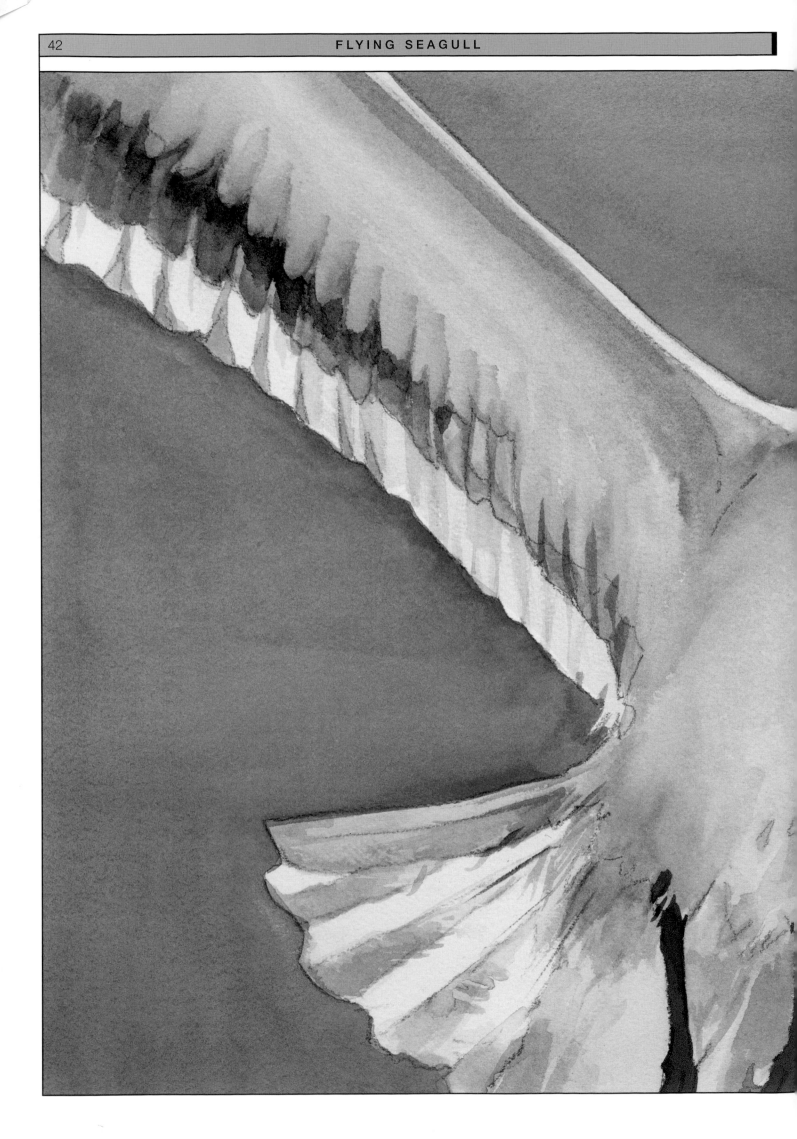

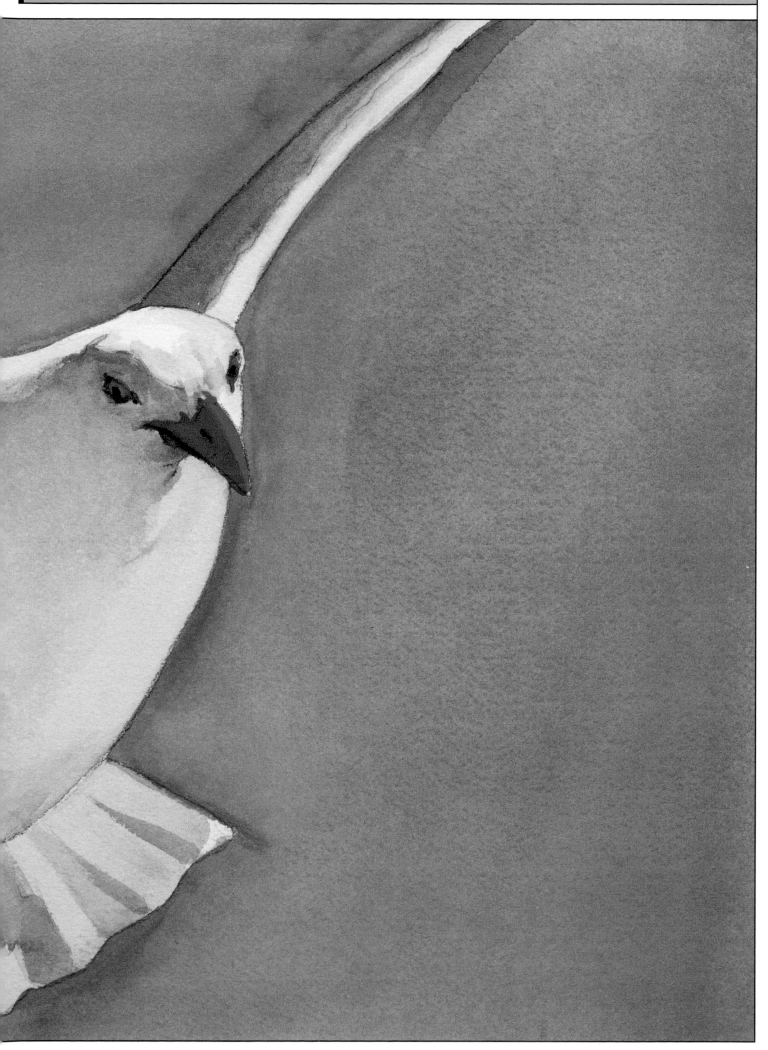

Suggestion for framing

Choose a basic frame to go with the simple elements of the painting, displaying the work without overpowering it. The color of the frame is an aged blue, with some attractive earthy shades. The single matting is white, in harmony with the seagull.

ADVICE

To ensure that the applied color has the desired intensity or transparency, test it on a piece of scrap paper and calculate the water needed to dilute it.

Types of pigment

Watercolor prices are determined by the quality of the pigment and the degree of concentration. Good quality pigment can take a lot of water without losing its vividness. The paint itself must be composed of at least 50% pigment. The pigments come from minerals ground into a fine powder. The finer the powder is, the smoother the application of paint. The opacity and intensity of pigments vary. Primary and secondary colors are usually very intense. Tertiary colors need more pigment, as they are less intense.

The pigment is the component that gives color to the paint. The rest are cohesive elements.

Leaving the white paper unpainted

The technique of watercolor does not use white. All tones have to be built up starting with the white of the paper. The paint becomes lighter the more water added to dilute the color. If the intention is to keep the color white in a certain area, avoid using any pigment in that area. Rather, the so-called "reserves" are used here. The first and simplest type of reserve is not to paint the area you want to keep white, and be careful with adjacent applications of color.

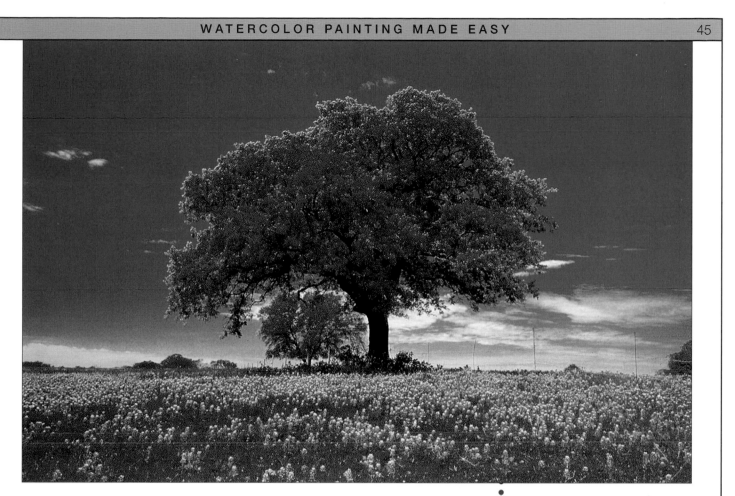

Solitary Trees

Nature always surprises us with its contrasts. Here a few trees in an open space present a striking motif for a painting.

Abundance of color

An initial objective of a landscape artist is the search for color. The beauty of a nature scene lies in the interpretation of light and colors. It is in landscapes that a painter can explore the boundaries of his palette, and discover the multiple combinations and nuances which can be present in one painting. The different seasons present endless possibilities, as cold and hot weather modify the colors and shapes of plants and trees. The beauty of fall, for instance, lies in the yellow, red, and orange tones of the leaves. These colors cannot be observed in any other season, except in memory. This arguably is the favorite season for many painters who like to work with the warm tones of their palette.

Complementary colors

This is, without doubt, one of the most effective procedures in painting. Complementary colors acquire their maximum strength when they are combined in the same composition. It's a way to create contrast based on color rather than light. However, complementary colors should not be applied with the same intensity; one has to be dominant, so that the colors do not cancel each other out. There are several ways to attain harmony between colors. With respect to the area occupied by each color, the dominant color should occupy the most visual space. Equally, the purity of the color is crucial. If you want one of the tones to dominate, the second tone needs to be less intense. Mix the latter to attain a tertiary color, and lower its intensity.

Brushes

Thin round-tip brush

Medium round-tip brush

Thick round-tip brush

Narrow flat-tip brush

Palette colors

Lemon Yellow	Cobalt Blue	Sap Green
Cadmium Orange	Ultramarine Blue	Sepia
Yellow Ochre	Hooker's Green	Burnt Sienna
Cerulean Blue	Olive Green	

Coloring the sky

1

Apply the blue colors with gradation. This means putting a lot of pigment in the upper part, and adding water as you approach the horizon line. In some areas, particularly in the lower part, leave the tone very transparent, imitating the clouds.

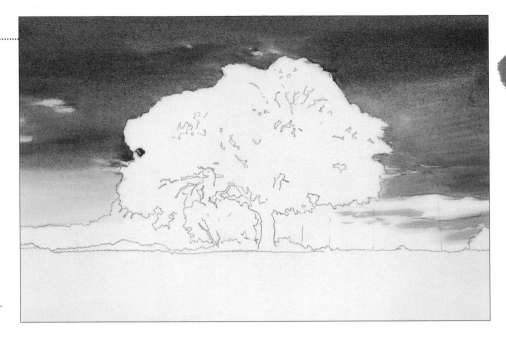

Cerulean Blue Cobalt Blue

Coloring the trees

2

Begin to apply the yellow tones with a little water to keep their intensity. Make a base color of lemon yellow, and while still wet, apply darker brushstrokes over it. The second tone is the result of mixing yellow ochre, cadmium orange, and olive green.

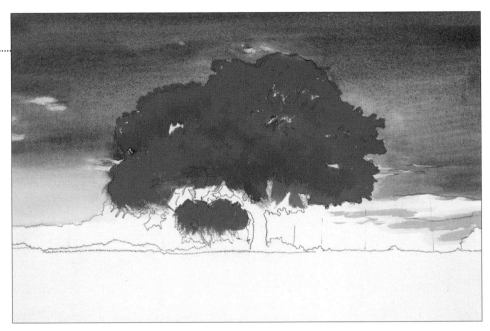

Lemon Yellow

Yellow Ochre Cadmium Orange

Olive Green

Working with warm colors

3

With the previous mixture, the area of the tree tops is established. Now darken the lower part. Color the land with lemon yellow, and apply cobalt blue over it, using a pointillistic technique — applying small brushstrokes or dots of color to give the appearance of a blended look.

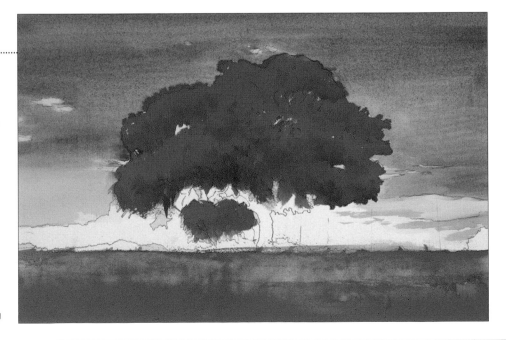

Cobalt Blue

Yellow Ochre Burnt Sienna

Olive Green

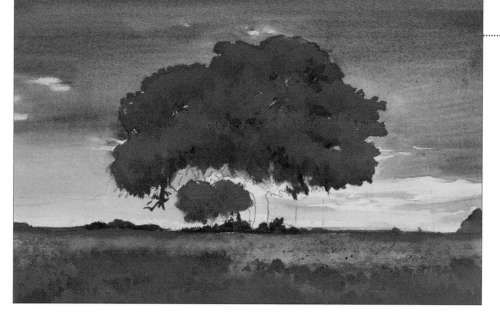

The darker tones

4

Applying yellow ochre and burnt sienna, intensifies the contrast of the tree's foliage. The thin brush-strokes will appear more defined in the lower part of the tree, where the base color is dry. Complete the whole lower part of the sky. Using olive green, applying the technique of little brush-strokes, gives shape to the foliage in the horizon.

Hooker's Green Sap Green

Yellow Ochre

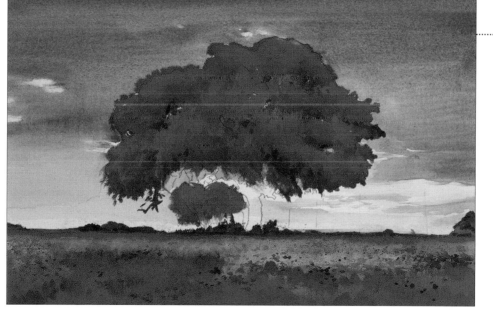

Applying new greens

5

Keep adding tones to the yellow of the tree and the ground, incorporating green colors. This time mix Hooker's green and sap green. Produce a darker value by applying trans-parent layers of color over a dried area. Keep working on the texture of the tree's foliage and the ground by applying yellow ochre brushstrokes to express lushness.

Burnt Sienna

Hooker's Green

Sepia

Ultramarine Blue

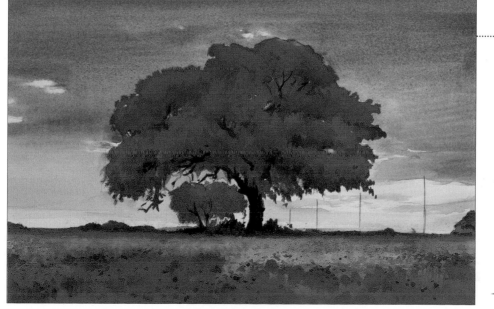

Final touches

6

To finish, define the shape of the trunk and branches by applying almost pure sepia with a thin round-tip brush. Keep applying little pointillistic touches of green and burnt sienna to the ground, using a medium round-tip brush. Apply ultramarine blue until the desired texture is gained.

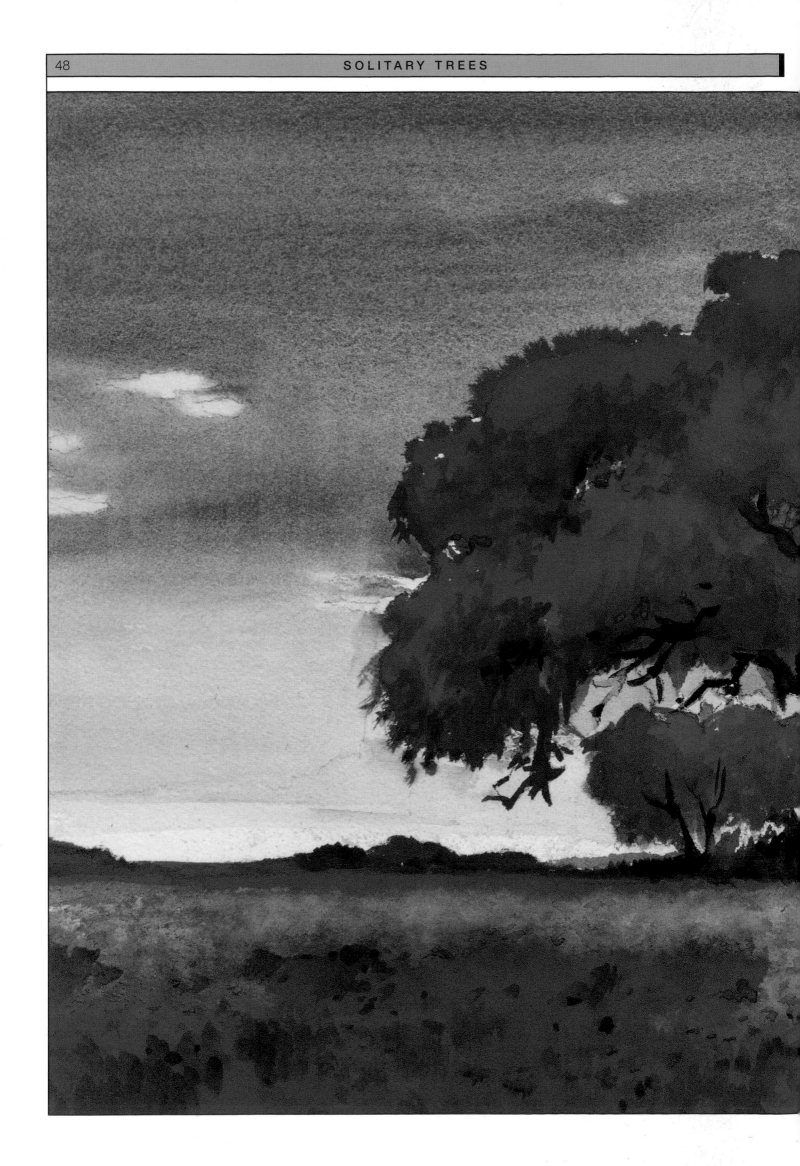

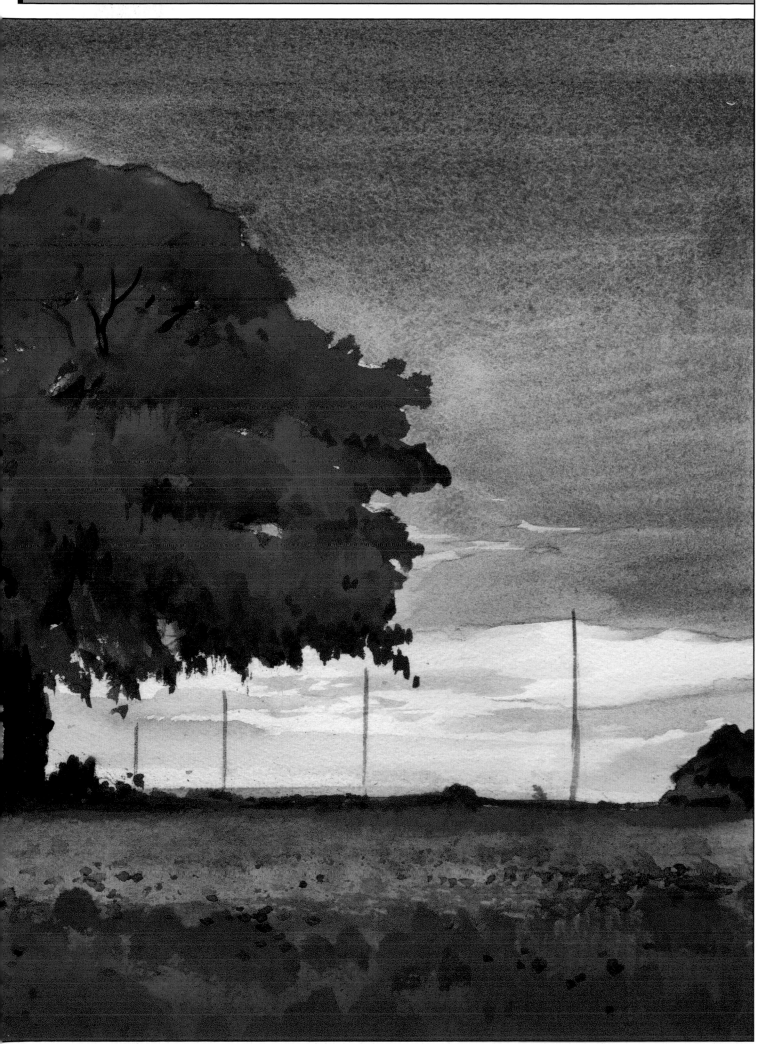

Suggestion for framing

For this brightly colored painting, use a
luminous modern frame. Recommend an
orange colored wooden frame that will
combine with the tones in the tree. Use a
double matting: a thin, white color interior
piece with a beige exterior to balance the
color of the landscape.

ADVICE

Wait for the sky area to dry
before beginning to paint the
tree; otherwise the yellow would
mix with the color of the sky.
It is very difficult to recover
a color after mixing
has occured.

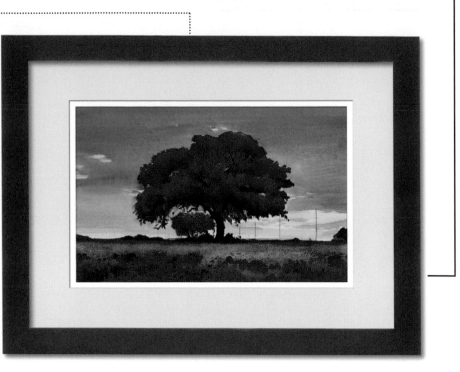

Pointillistic and splashing technique

All liquid or soluble types of paint can be used with a
pointillistic technique. This technique allows for the
creation of various visual textures, such as sand, stone,
stars, masses of leaves, flowers etc. It would be very time
consuming to apply the paint spots, one by one. A good
way to apply the splashing/small strokes technique is to
soak a used toothbrush and flick the bristles onto the
paper. The ink will splash in a very irregular manner.

To avoid splashing to undesired areas, recommend protecting these areas
with a piece of paper. The sky, for example, remains smooth, in contrast
with the land.

Composition of watercolor paints

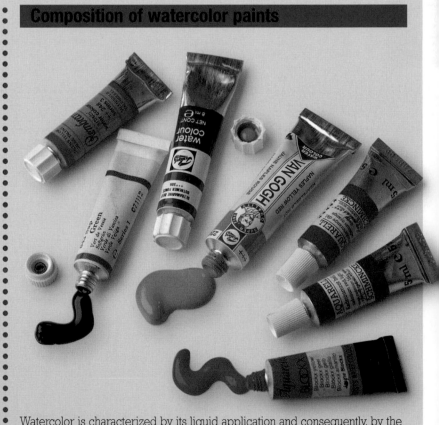

Watercolor is characterized by its liquid application and consequently, by the
transparency of its colors. Watercolor paints must include special cohesive
and water-based elements, apart from good quality pigments. The paint's
stability depends on the cohesive elements; these ensure that the painting
will not crackle. The main cohesive element in watercolor is purified natural
Arabic gum. The gum, dissolved in water, makes the pigment flow in a sponta-
neous and even manner. Glycerin helps the pigment retain moisture. Some
makers include honey in the pigment composition to produce a shiny finish.

Arizona landscape

The beauty of nature is dramatically present in desert landscapes, where the bright, golden colors of rocks and sand predominate, in contrast with the intense blue sky.

Creating distance

In flat landscapes, the Earth and sky unite at the horizon, creating the line of maximum distance. This line determines the position of any element placed in the foreground. Here, the mountains define the distance from the horizon line. The elements in the foreground are not big enough to conceal the landscape's perspective. On a second plane are the mountains, and behind them, the different plateaus and rocks in the distance. In the background, the small hills are placed directly on the horizon line.

Expansive skies

Skies are very attractive and accessible to any painter. An outdoor scene or a view through a window naturally presents the sky's pictorial possibilities. You can have cold winter scenes, gray fog, overlapping white clouds, or warm, orange sunsets and blue skies with a radiant sun. In any painting about the sky, you have to establish the Earth's horizon to understand the position of the sky. Although this scene can be represented by means of any painting medium, watercolor, given its transparent character, allows the mixing and gradation of colors more easily. Watercolor is ideal to express the vaporous nature of the sky.

Brushes

Thin round-tip brush

Medium round-tip brush

Thick round-tip brush

Palette colors

Yellow Ochre	Hooker's Green	Burnt Sienna
Cerulean Blue	Sepia	Permanent Violet
Prussian Blue		

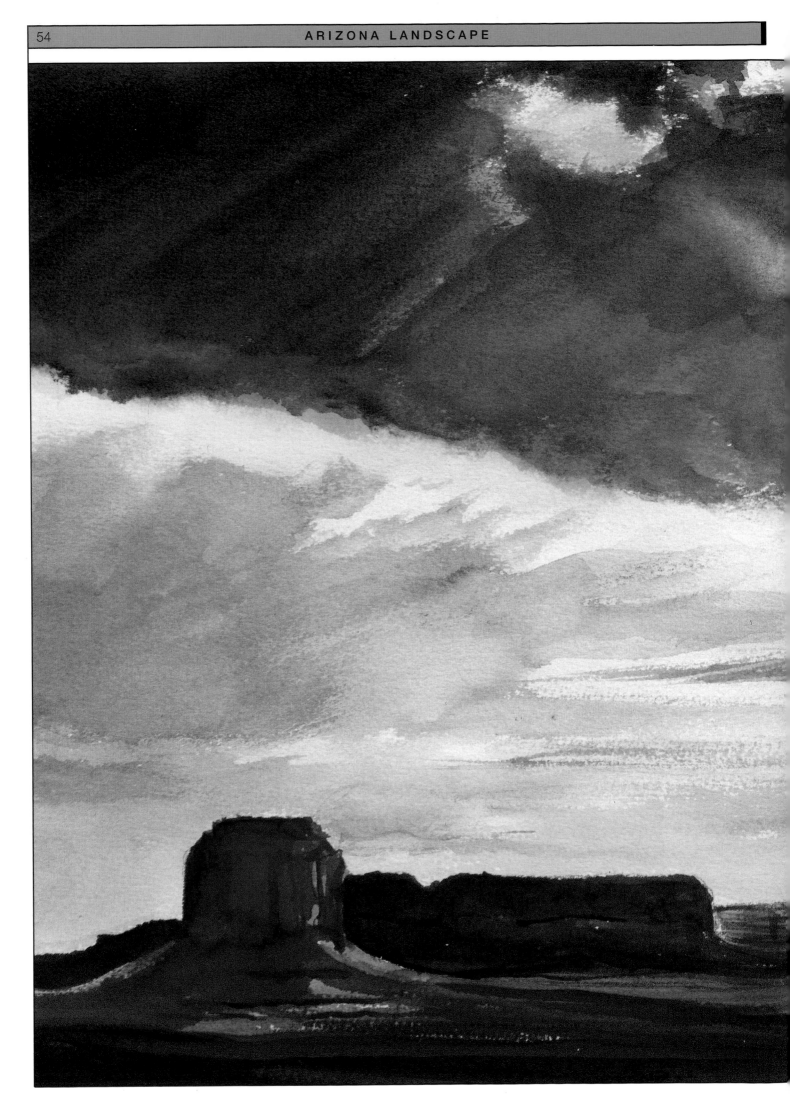

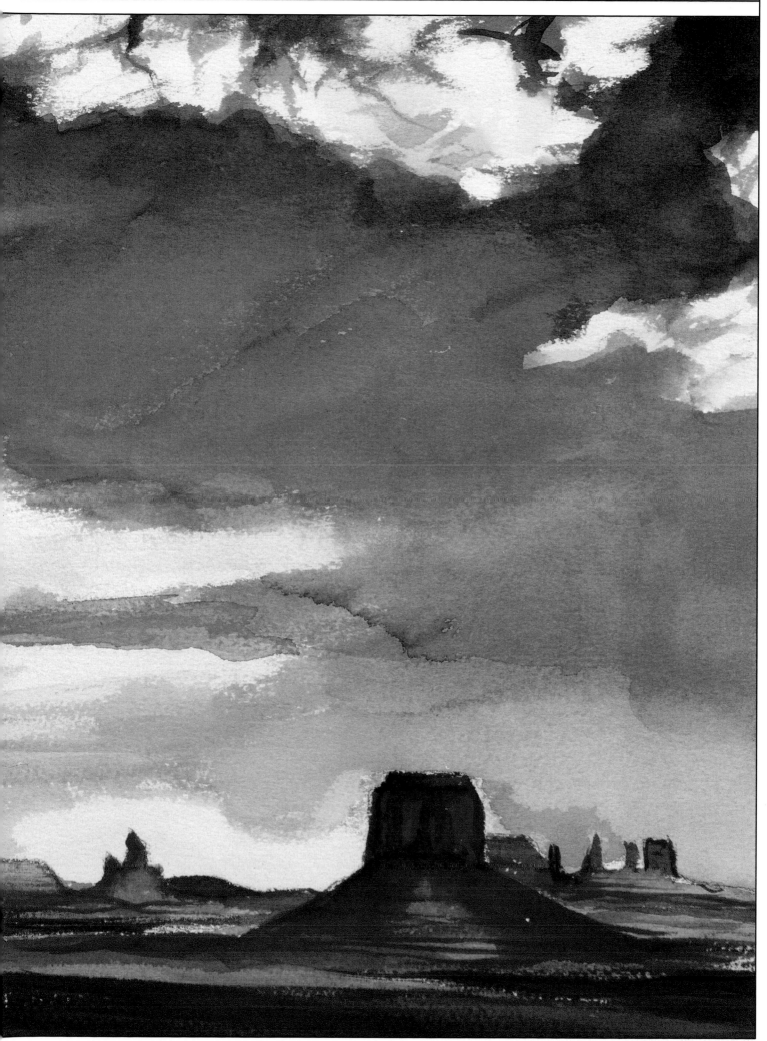

Suggestion for framing

Choose a wide, reddish-brown frame in a color related to the land. It can be a very elegant frame with a smooth and polished texture. Use simple white matting, so the balance between the frame and the earthy colors is emphasized.

ADVICE

To produce the expansive gradation of the sky, use a thicker-nib brush. Fill it with a lot of diluted pigment so the brushstrokes are not visible.

Cleaning and maintenance of equipment

The cleaning of the materials in watercolor is very simple. This type of painting can be easily reworked after it dries. As soon as water is applied, it becomes workable again. Given this, the residual colors on the palette do not have to be cleaned after each session. You can always use them again. Brushes are simply cleaned with running water.

The dried pigment on the palette can be recovered as if it were a watercolor block.

Tubes must be closed to avoid the paint from drying. Also, make sure the threads are clean.

Washing a color

Watercolor, as a liquid technique, involves many treatments with water. Water allows you to dilute the pigment, as well as to correct mistakes. Because of its tendency to stick to the paper, the drier the pigment, the more difficult it is to wash. It may require several application of water with a brush until the pigment is fully removed. The intensity of the paint to be washed is also a factor — very intense and dark colors can be diminished, but may never be completely removed.

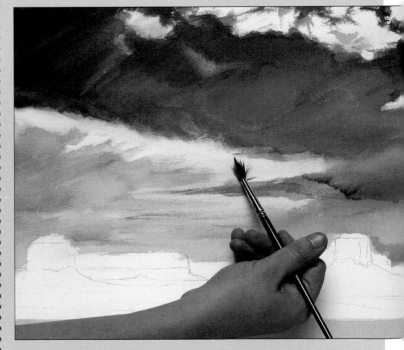

Here, the pigment has been applied in a soft manner, so it is easy to recover the white by washing it several times with water.

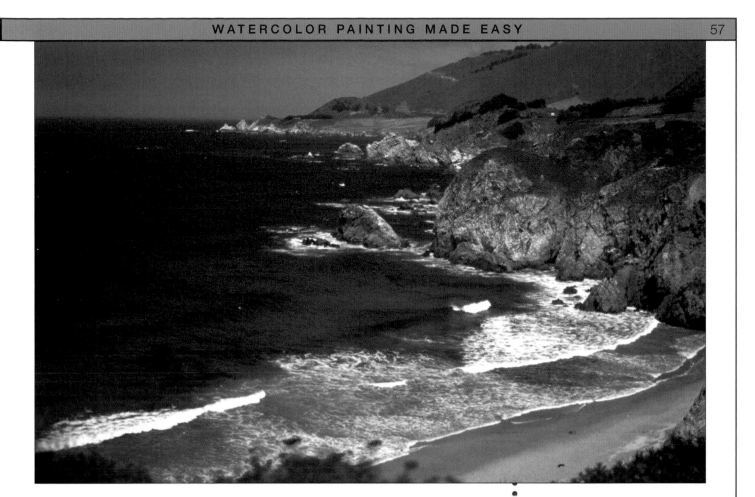

Seascape with rocks

The sea is a popular subject of the many artists who enjoy outdoor painting. It often requires the use of quick and loose brushstrokes to express the ever-changing movement of this fluid landscape.

Painting quickly

Painting seascapes gives the opportunity for many interpretations, as well as modifications of color, composition and technique. There is no need to study this environment in a long and detailed manner. You work in a quick and loose manner as if you're sketching fluid forms in nature. For this reason, quick painting gives the potential to represent these characteristics in a more accurate manner. The completion of light and composition studies are good practice for further, more elaborate projects. Watercolor is the most flexible medium for quick painting, given the ease of application in combination with water, to reflect the natural character of land and water.

The colors, step-by-step

There are two basic techniques of painting: by gradation of colors or by organizing different flat colors in contrast. Both methods are valid and offer different results. The former yields a very spontaneous painting in which colors spring from the different mixtures with water. The latter, a more elaborate method, results from the different mixings and values initially created on the palette. The colors here are flat, and each one occupies a determined area. The ensemble of the entire area creates the different forms. This type of painting needs a good drawing base in which the area designated for each tone is well established. Here, shadows can be established by adding values. The different colors, applied step-by-step, offer a simple way of painting.

Brushes

Medium round-tip brush

Thick round-tip brush

Medium flat-tip brush

Palette colors

Lemon Yellow	Permanent Crimson	Hooker's Green
Cadmium Orange	Cerulean Blue	Sap Green
Yellow Ochre	Cobalt Blue	Sepia
Cadmium Red	Ultramarine Blue	Burnt Sienna

Greens in the foreground

7

In visualizing the approach to the foreground, the green color becomes brighter and more intense to reinforce the impression of proximity. Achieve this by adding less and less water to the mixture. This mixture is now composed of yellow, orange and Hooker's green.

Lemon Yellow　　Hooker's Green

Cadmium Orange

The first dark tones

8

To this point you have been working with a lot of water. Now, define the darker bushes by using a mixture of Hooker's green, cobalt blue, and burnt sienna to obtain an intense color, which becomes darker as you add less water.

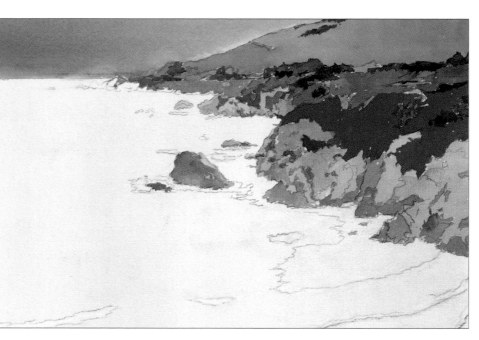

Hooker's Green　　Cobalt Blue

Burnt Sienna

The base color for the sea

9

Paint the surface of the ocean evenly with a very light color. Use a greenish blue obtained from a diluted mixture of cerulean blue, ultramarine blue, and Hooker's green.

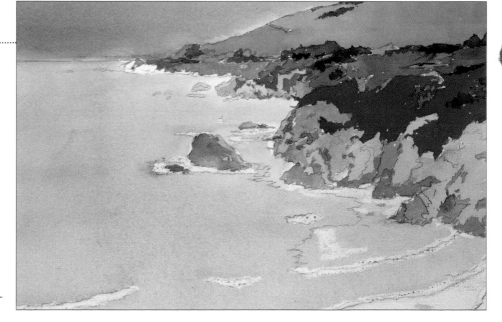

Cerulean Blue　　Ultramarine Blue

Hooker's Green

Cobalt
Blue

Ultramarine
Blue

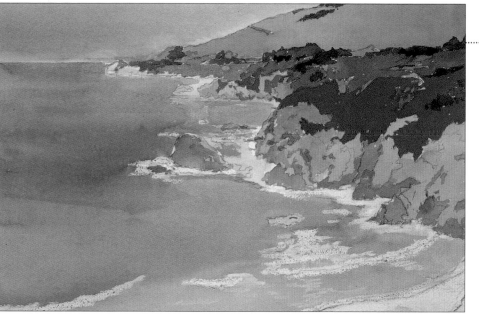

Darkening the color of the sea

10

Using a flat-tip brush, apply a new color, a mixture of cobalt and ultramarine blue. The application of this color on the still wet base tone will blend them creating a new tone.

Ultramarine
Blue

Sepia

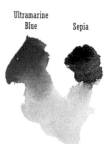

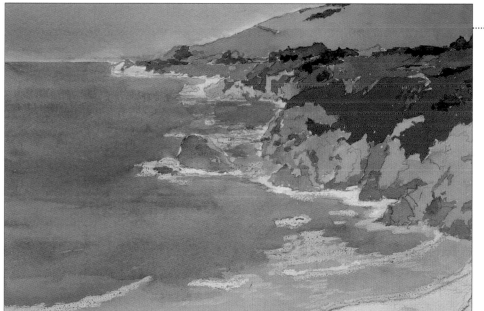

The grays of the sea

11

Now add some new tones to the foreground of the sea to accentuate the transparency of the sand. Mixing ultramarine blue and sepia creates a cool gray tone that is applied to the areas close to the waxed area.

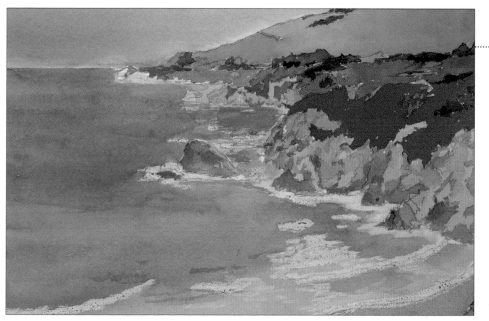

Painting the foreground rocks

12

Using the same gray, color the rock in the foreground. While using a lot of water for the sand to obtain a brighter tone, conversely, with the rock, use much less water to achieve an intensified color.

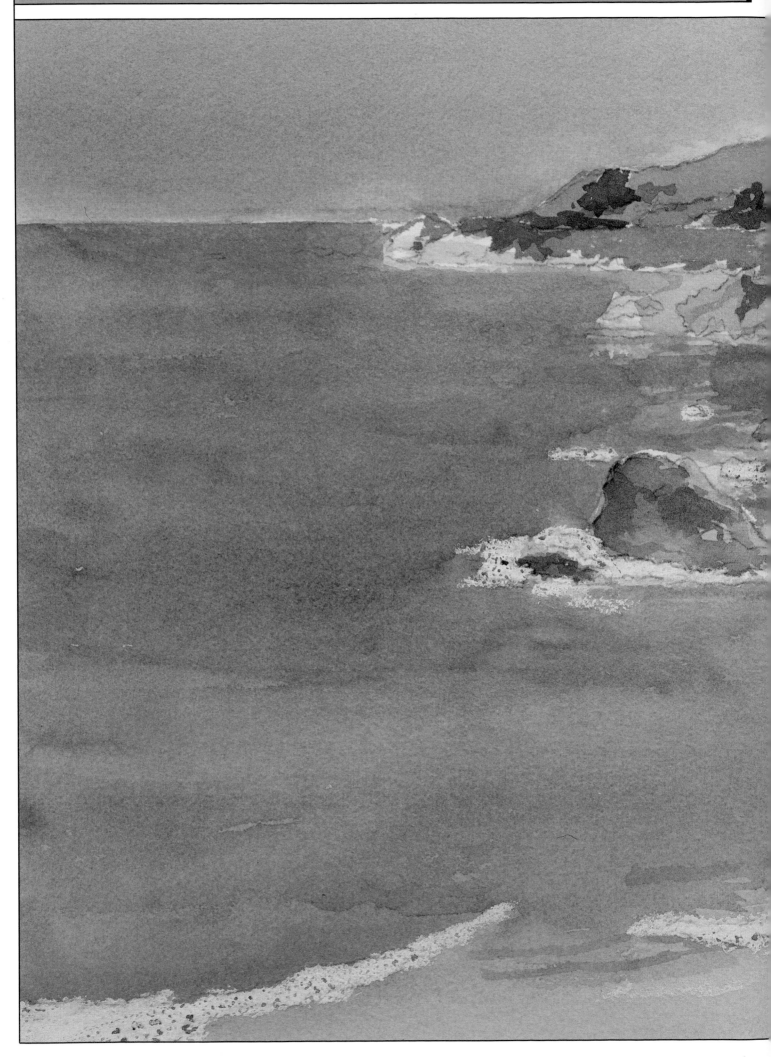

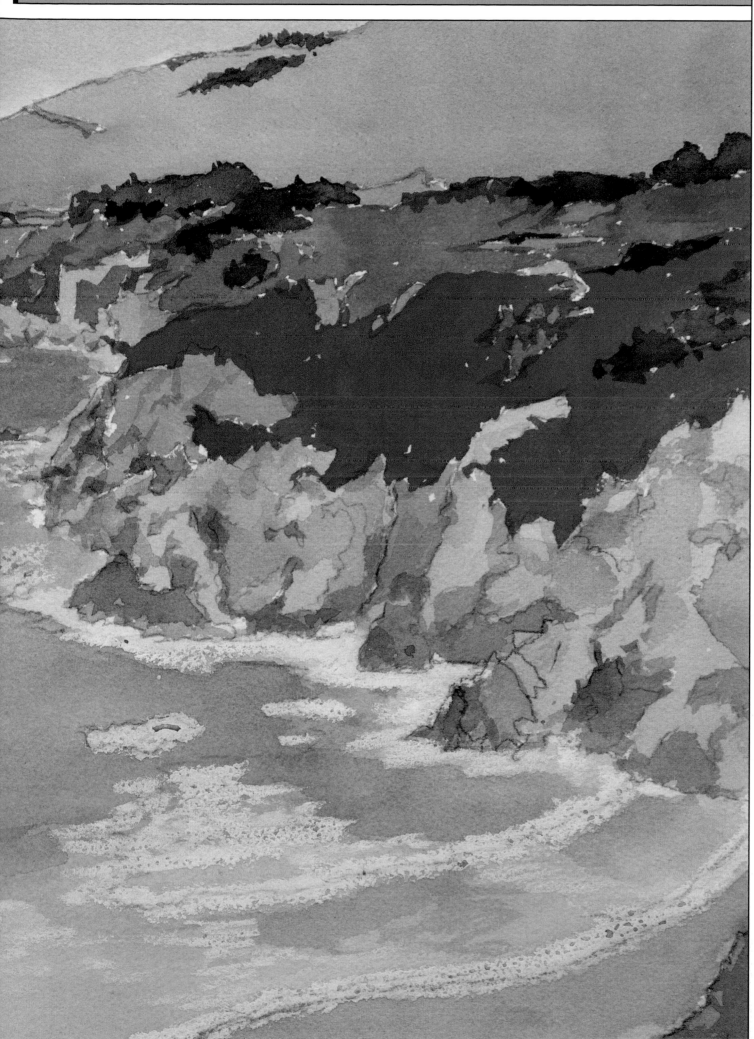

Suggestion for framing

For this painting consider a wooden frame in a warm color with dark grain that coordinates with the yellow ochre in the rocks, and contrasts with the dominant grays and blues. Use double matting: a thin white inner matt to match the sea foam, and a gray outer matt to complement the rocks and ocean, but contrasts the frame.

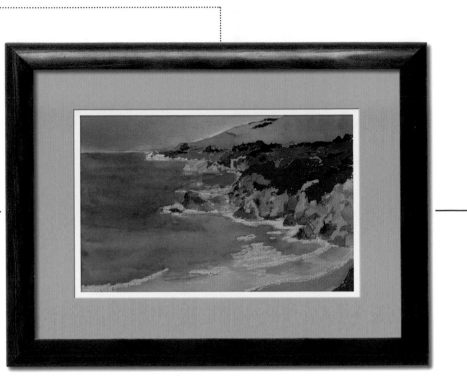

ADVICE

When painting the water, to make a gradation with the first and second tones, it must be done before the first tone dries. It's the only way both tones will blend and the brushstrokes will not show.

Reserving white with wax

Use wax for making reserves because of its impermeability to water. Wax is an oily medium that will repel any water solution when applied. You can use candle wax or wax crayons. Since it is very difficult to remove wax from any surface, plan in detail the areas where wax is to be applied. The application should be made in a very precise manner. Generally, the reservations are clearly delineated. As color is applied to them, minuscule drops appear on their surface.

In order to make reserves for the sea foam, carefully apply touches of hardened wax imitating the shapes of the waves.

Building up tones

In most painting techniques, the tonal values are built up by applying white. This is not the case in watercolor painting, where the values are built by incorporating water. The more water added, the more transparent a color becomes, since the white of the paper will lighten it. The most intense color exhibits the highest proportion of pigment. It is difficult to calculate the desired intensity. For this reason, it is very useful to practice with value scales. An easy way to do this is to compare a basic tone, with tones resulting from adding a measured drop of water. The proportion of water has to be identical each time to ensure an accurate color scale.

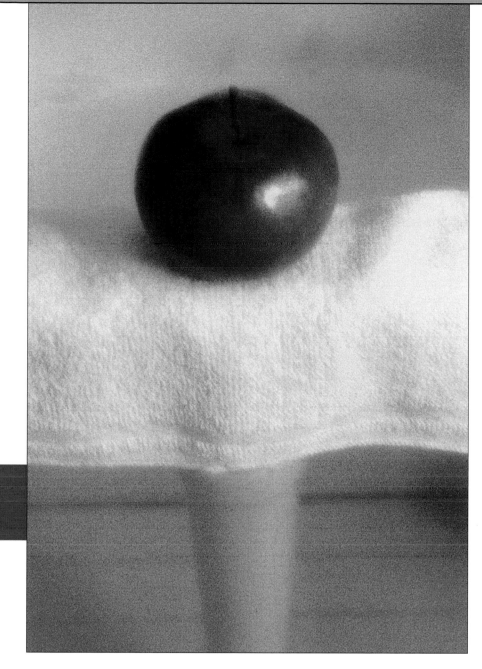

An apple on the table

One of the best subjects to use in beginning painting is depicting simple elements such as fruit. By starting with one piece of fruit, the task is easier, the chance of success is higher, and you build confidence.

Basic forms

Paul Cézanne, one of the masters of modern painting, was the first to observe that all things could be reduced to simple forms such as the cylinder, the cube, and the sphere. By interpreting the basic form of objects, the task of tracing lines to show perspective is simplified as well. The cubist movement developed observations including other basic elements such as prisms, cones, triangles, and ovals. The point here is to identify and draw the basic form that best suits the model. Once done, you can calculate its real measurements, shape and proportion.

The sphere

A sphere can be used as the basic form for most fruits. Obviously, the details of the real object are not fully represented, but its shape is. Spherical objects cannot be represented in painting with simple gradations, as in a flat surface. Although round forms follow a gradation from light to dark, they must have the same visual rhythm as the contour, namely a circular direction. The brightest point is a set circular point. Around this point, develop all the tonal changes, applying darker circles until the maximum tonal intensity is realized. When all the tones are blended, a spherical shape results. This method can be applied to any curved form.

Brushes

Thin round-tip brush

Medium round-tip brush

Thick round-tip brush

Narrow flat-tip brush

Wide flat-tip brush

Palette colors

Lemon Yellow	Permanent Crimson	Olive Green
Cadmium Yellow	Cerulean Blue	Sepia
Cadmium Red	Ultramarine Blue	Burnt Sienna

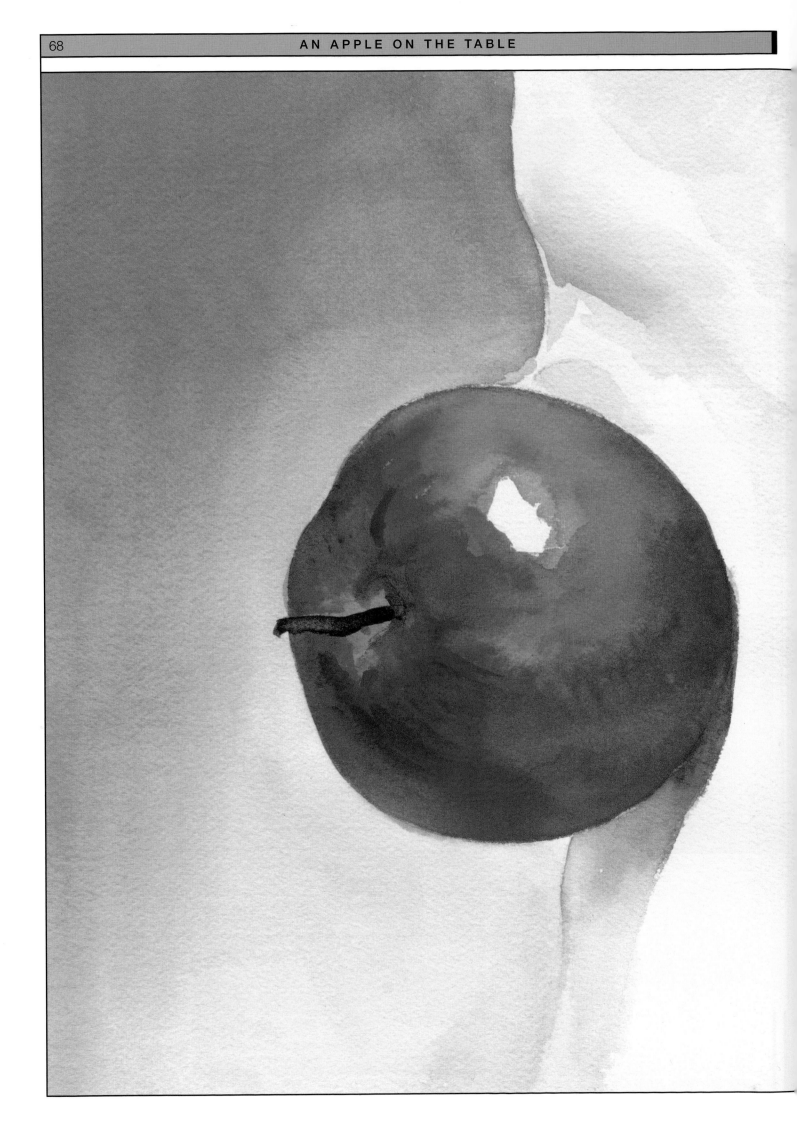

Suggestion for framing

Choose a simple frame in harmony with this composition of few elements. Plain white matting enhances the apple's lively color. The frame is a pale and neutral colored wood, a tone in concert with the background of the image.

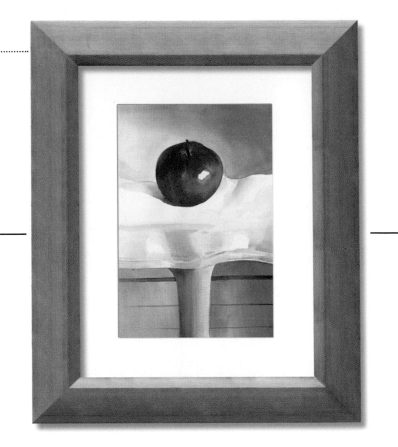

ADVICE

Use a wide round-tip brush to cover the smooth background in a uniform way. Complete the background before applying any other tone, giving you a color for reference.

Overlapping color

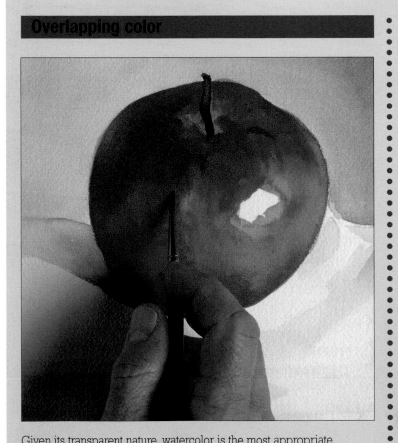

Given its transparent nature, watercolor is the most appropriate technique to achieve tonal overlapping. Each color modifies the one underneath, creating new values and tones — in this case, the combined layers of red over yellow. Bright orange will appear in the areas where the color has been applied in a diluted manner. The red should stand out over the yellow and orange tones.

Types of watercolor paper

Watercolor paper, regardless of its quality and weight, can be found in loose sheets, rolls, pads and books. The standard measurements for the sheets are: 12 x 16, 14 x 20, 16 x 20 and 22 x 30 inches. These can be cut into smaller sheets. Rolls are popular among professional watercolor painters because they are the most economical, and offer the chance to work in any format. Pads and books are easier to transport and are available in several formats and sizes. Some books are adhesive bound and others are spiral bound.

Bird in water

In this scene, the natural sunlight and reflections on the water enhance the bird's beauty.

The color spectrum

The color spectrum is composed of two schemes, cool and warm. Blue is the coolest color, followed by some greens and violets. These colors become warmer as more warm pigment is added to their composition creating, for example, yellowish greens and crimson violets.

How to classify the neutral colors? Classify the grays as cool neutral colors, and browns as warm neutral colors. However, this is not a strict rule. When assessing a neutral color, identify the amount of red or yellow in it, making it a warm tone, or the amount of blue or violet, yielding a cool tone.

Nature subjects

The representation of birds and animals is a stimulating and gratifying experience for the painter who admires and respects nature. In the beginning, representations of animals had a scientific goal. This was done to capture their formal characteristics for anatomical studies. Later, nature scenes of hunting or training animals were created with the human component often portrayed as more important than the animal. Nowadays, the representation of animals is an artistic and decorative practice, in which the strength of the brushstroke can appropriately express the nuance of nature. Although it may be more tempting to represent big and powerful animals, often you find greater beauty and color in small ones, like the small bird in this scene.

Brushes

Thin round-tip brush

Medium round-tip brush

Thick round-tip brush

Narrow flat-tip brush

Medium flat-tip brush

Palette colors

Lemon Yellow Cerulean Blue Burnt Sienna

Cadmium Orange Cobalt Blue Ivory Black

Cadmium Red Ultramarine Blue

Background color

1

Apply diluted color with wide horizontal strokes using a thick round-tip brush. The color is greenish, a mixture of cerulean blue and lemon yellow, and is more obvious in the upper part of the painting. In the lower part, intensify the blue. Using a narrow flat-tip brush, apply some strokes of cobalt blue, which blends with the background.

Cerulean Lemon
Blue Yellow

Cobalt
Blue

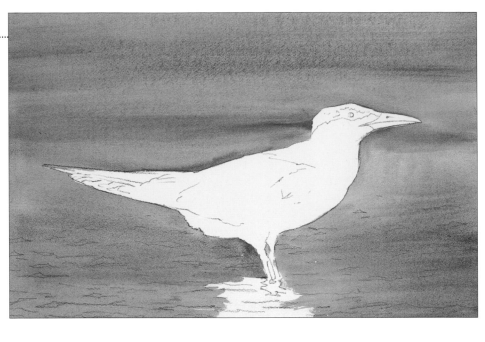

First details in the water

2

Continue to include details of cobalt blue in the center and in the foreground. Using a medium round-tip brush, paint the area of water in which the bird is reflected with lemon yellow.

Lemon
Yellow

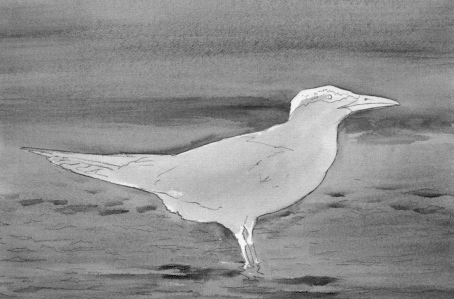

Coloring the body

3

Create a gray with a mixture of cerulean blue and burnt sienna, and distribute it over the bird's entire body, although not in a uniform way. On the right, intensify the color, while in the center add enough water to make it transparent.

Cerulean Burnt
Blue Sienna

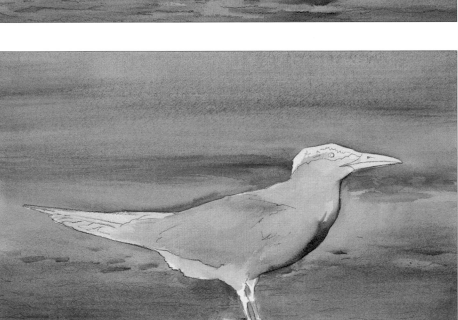

Ivory
Black

Lemon
Yellow

Cadmium
Orange

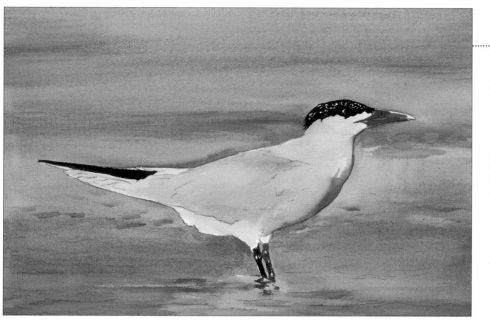

The first details of the bird

Using pure black and a thin round-tip brush, define the head, legs, and main feathers of the bird's tail. Leave some small white dots on the head, as well as in the eye. Using the same type of brush, color the beak with a mixture of lemon yellow and cadmium orange.

4

Cadmium
Red

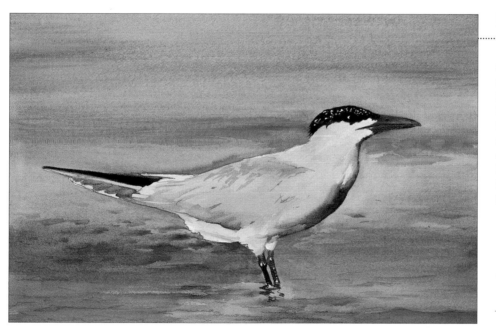

Defining the feathers

With a mixture of blue and burnt sienna used to color the body, add detail to some of the feathers. Using the tip of a medium round-tip brush, apply little brush strokes imitating the feathers. Add cadmium red to the bird's beak, and touch up the black lines of the beak using a thin round-tip brush.

5

Ultramarine
Blue

Cadmium
Orange

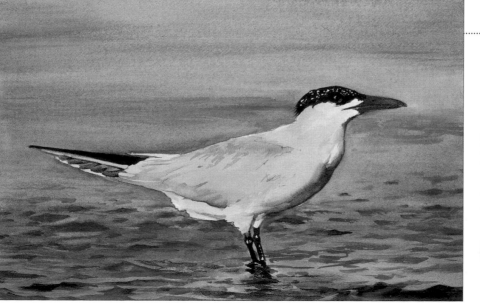

Final reflections on the water

To finish, apply horizontal brushstrokes in the foreground of the water imitating its ripples. The colors here should be ultramarine blue and black, much darker than in the background. In the area of the bird's reflections, alternate brushstrokes of ivory black with strokes of cadmium orange.

6

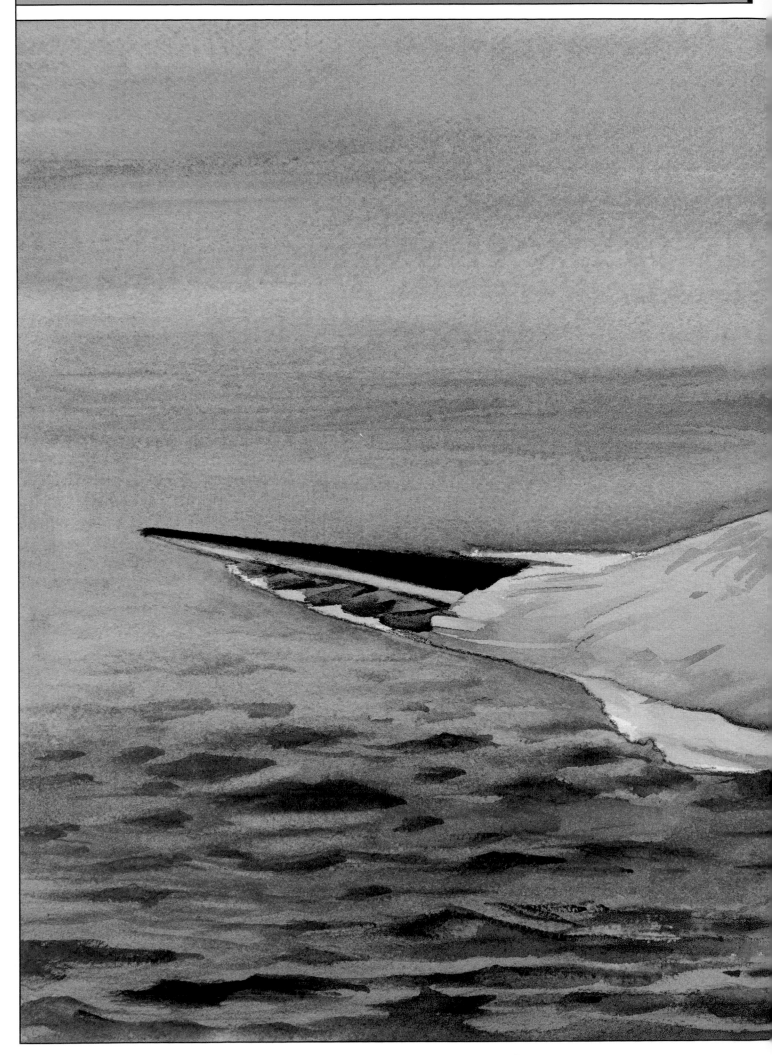

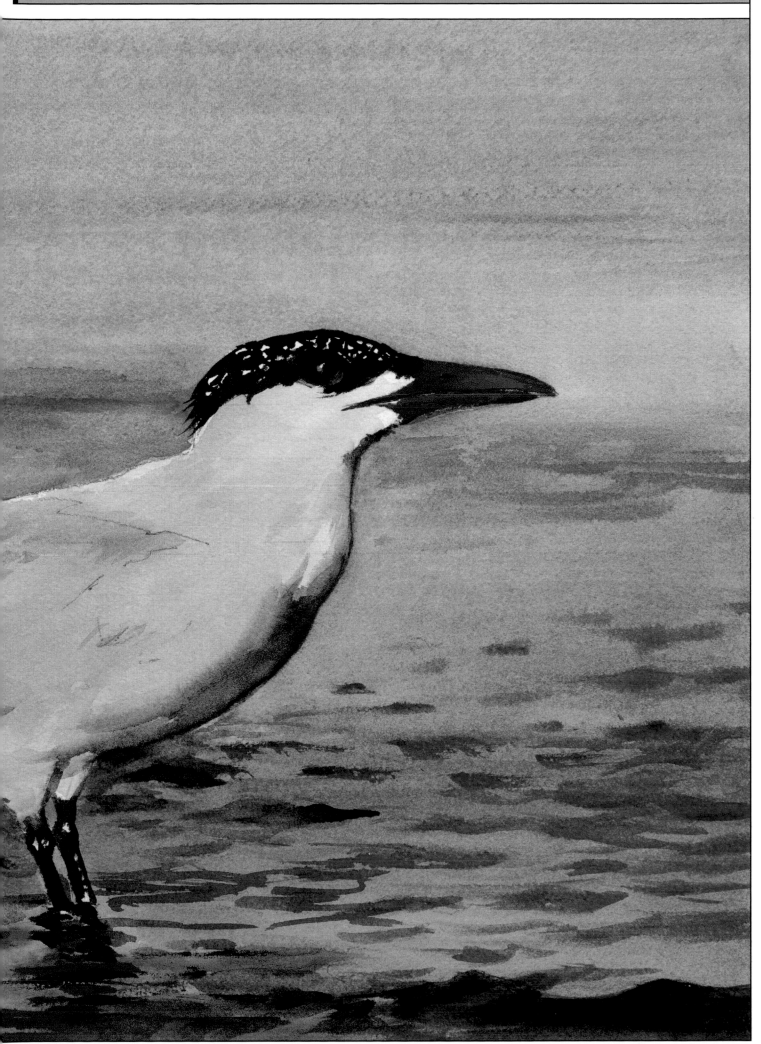

Suggestion for framing

The tone of the frame for this painting should
complement its lively and spectacular colors.
A thin, black smooth frame will be in harmony
with the darker feathers of the bird. Use
double matting — white for the inside matt
and a cream-colored outer matt in balance
with the warm colors of the bird, punctuating
their importance.

ADVICE

To complete step one, in
which blue brushstrokes are
applied over a greenish tone, act
quickly before the first layer
dries to achieve the proper
blending of colors.

Rendering the bird's silhouette

Although watercolor can be a very spontaneous and fast
medium, you can achieve very detailed and precise finishes,
with proper application. For precise details, use thin brushes
carefully. A thin, no. 0, round-tip brush is perfect for details,
although any brush with a pointed tip can be used.

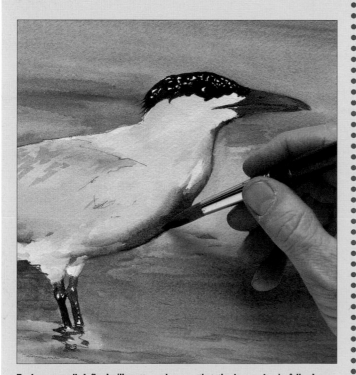

To draw a well defined silhouette, make sure that the base color is fully dry
so that the pigment does not bleed over it.

Brush shapes

The shape of the brush is crucial for the stroke, and ultimately for the
result the painting achieves. Apart from the quality of the hair, brushes
are classified as follows: Round, with a cone shaped body and pointed
end that are ideal for ample paint and defined lines by using the tip.
A flat brush is very useful to define limits or to emphasize the brush-
stroke. The fan-shaped brush is useful for flat, wide backgrounds.
Japanese brushes are mounted on cane with long hair, and are
extremely flexible.

Different watercolor brushes and their corresponding brushstroke.

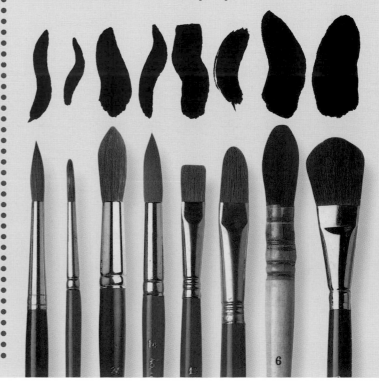

6

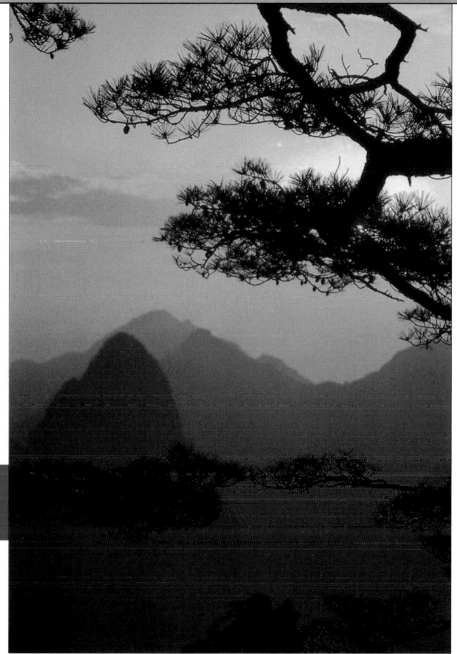

Japanese landscape

The beauty of this calm landscape with its warm tones reminds one of Japanese nature scenes beautifully and simply rendered with ink and water.

Working with ink and brush

There are two types of brushes to work with ink — the sable hair, and the Chinese brushes. The latter were used in ancient China and have barely changed over time. They are very much appreciated by artists because of their expressive versatility. They are used in a vertical position either to delineate very thin lines or very thick ones, as well as other applications. When painting with ink and brush, as opposed to drawing with pen, add water to the ink to obtain different tones of gray. You can also use ink as a drawing medium with an almost dry brush to create detailed line art.

Sumi-e: Japanese watercolor

Japanese watercolor, or sumi-e, is a traditional technique of representation that reached the West in the 18th century. This artistic technique is one of the most classic in ink drawing. It is characterized as monochromatic for having very few colors. This technique combines all the possible combinations to be made with ink, from wide fading backgrounds, to precise lines for the main elements in the foreground. In general, a long and thin brush is used sidewise to fill large extensions of color, and vertically to create thin lines. Many themes are represented with this technique, although the most frequent ones are the landscapes of mountains that combine large expanses of color with fine details.

Brushes

Thin round-tip brush

Medium round-tip brush

Thick round-tip brush

Narrow flat-tip brush

Medium flat-tip brush

Palette colors

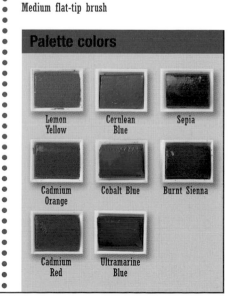

Lemon Yellow	Cerulean Blue	Sepia
Cadmium Orange	Cobalt Blue	Burnt Sienna
Cadmium Red	Ultramarine Blue	

The base color of the sky

1

First, apply a very transparent yellow for the sky. Then, using a very diluted mixture of cobalt blue and burnt sienna, apply small brushstrokes of this tone on the still moist base color, imitating the clouds.

Cobalt Blue **Burnt Sienna** **Lemon Yellow**

Gradation of the mountains

2

Apply a very diluted wash of orange from bottom to top. In the area limited to the sky, add a very diluted mixture of orange, red, and cobalt blue, so the color appears transparent over the white of the paper.

Cadmium Orange **Cadmium Red**

Cobalt Blue

The warm colors

3

Now enrich the colors of the mountains with soft layers of orange to differentiate them. Make tertiary colors by adding blue. For the lower and middle areas of the mountain, mix sienna, red, and a bit of cobalt blue. For the mountains in the background, mix sienna with cerulean blue. Apply a lot of water in both cases.

Cadmium Red **Burnt Sienna**

Cobalt Blue

Cerulean Blue **Burnt Sienna**

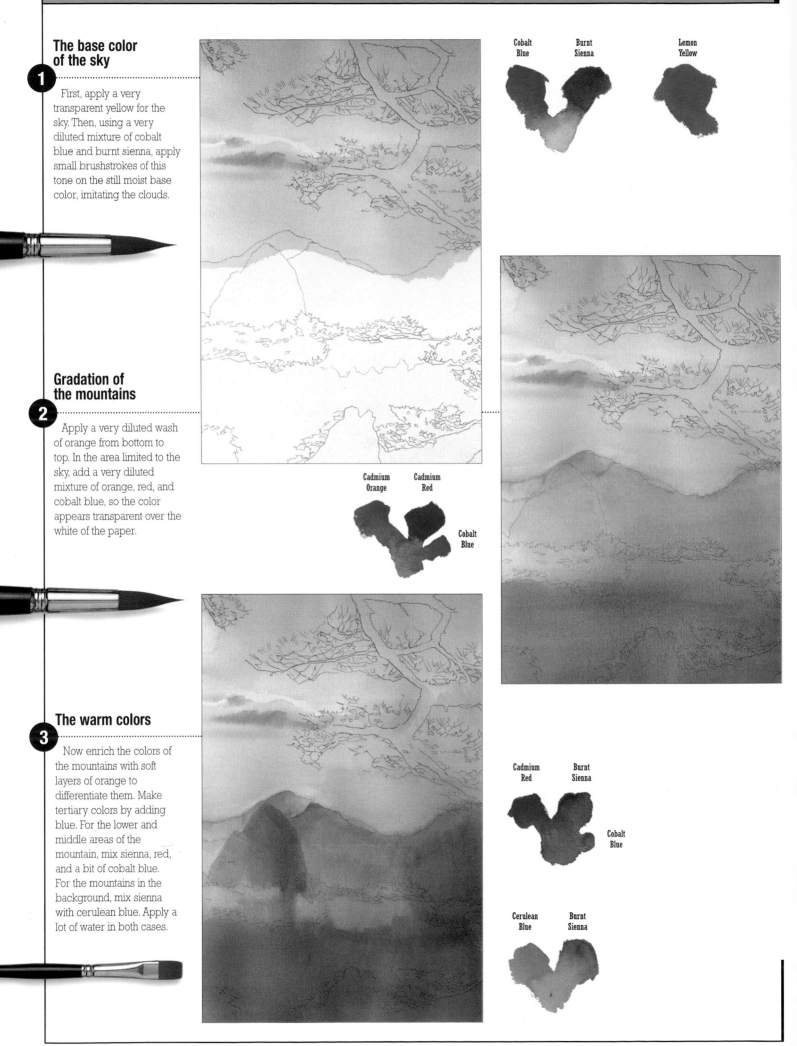

Ultramarine Cadmium Sepia
Blue Red

ADVICE

Working with watercolor here is based on a combination of soft, blended colors, and knowing the proper order to apply the details. Knowing a pigment's drying time is crucial to achieve these effects.

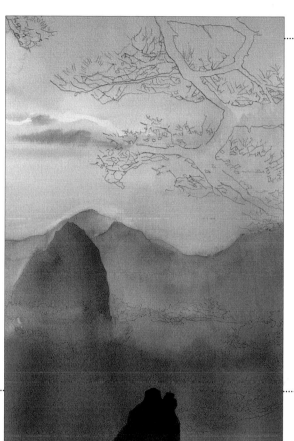

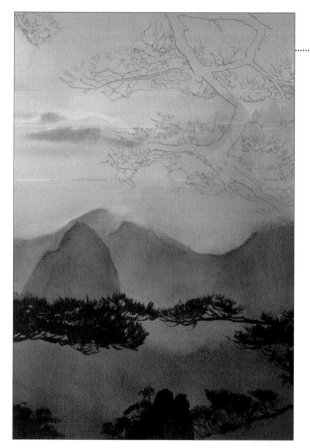

Cadmium Sepia
Red

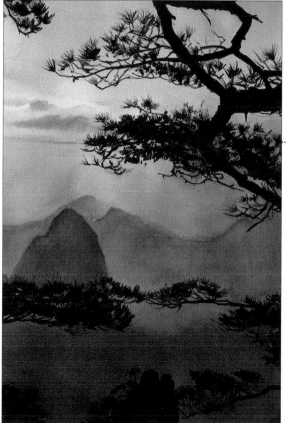

Cerulean
Blue

First contrasts

4

Now differentiate the middle area of the mountain with a violet hue by using a very diluted mixture of ultramarine blue and red. In the foreground, use pure sepia to create the first dark color.

Beginning with the branches

5

Using sepia directly, begin to define the branches and the leaves in the lower part of the tree, which covers a wide area of the mountains. Work with a flat brush on the branches, using a mixture of red and sepia. For the little leaves, however, use a thin, round-tip brush.

The final step

6

To complete the work, draw all the branches and leaves on the upper area. The application of sepia will establish a contrast between dark, well-defined lines, and the soft background. Lastly, add more detail to the sky with very soft cerulean blue.

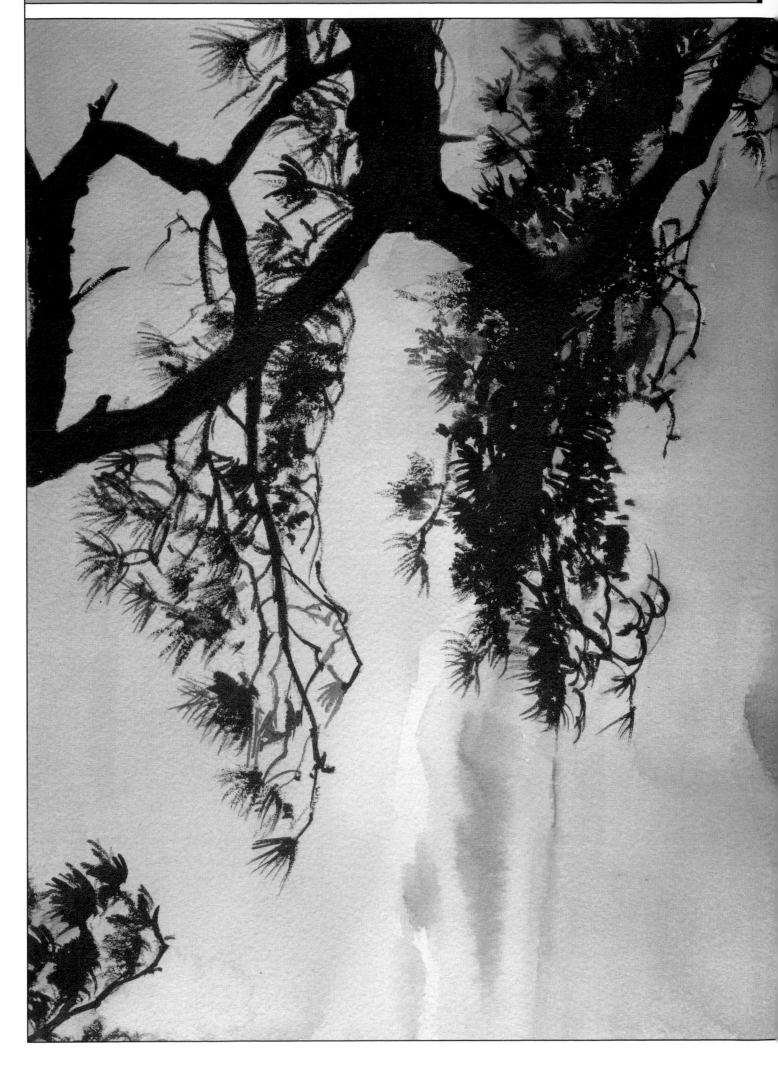

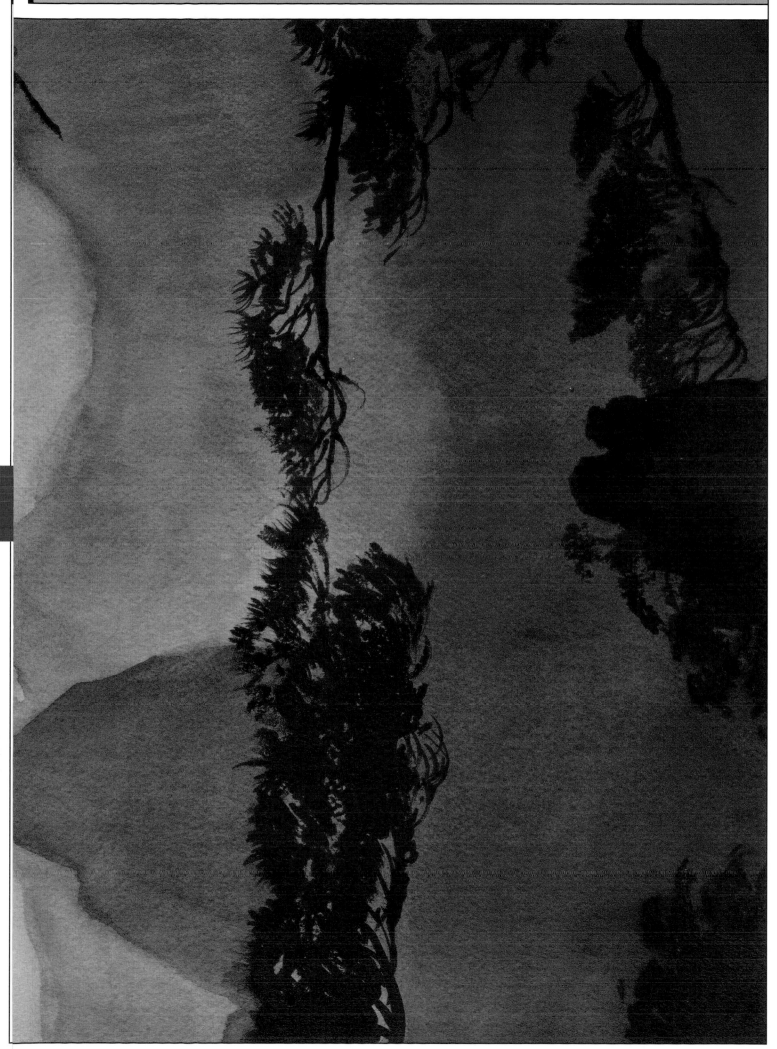

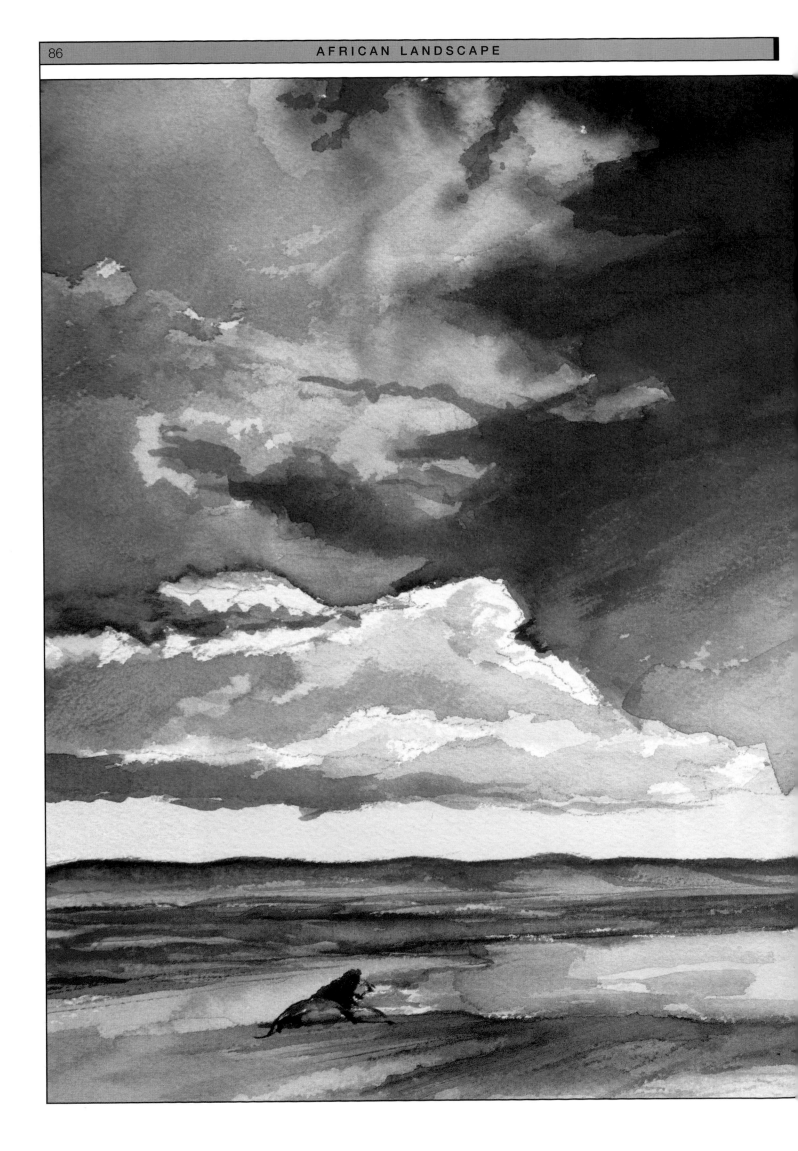

Suggestion for framing

For this broad and complex scene, look for a frame and matting corresponding to the colors and mood of the artwork. Choose double matting, to give the framing tonal variety. The inner matting is white, which brings light to the painting; the outer matt is gray, in harmony with the clouds and their stormy appearance. The frame is a bluish gray tone, neutral, yet dark; a color that combines with the tones of the painting, emphasizing the depth of the blue sky.

ADVICE

In order to obtain a continual gradation for the sky, work at a good pace. Once the paint is dry, and the brushstrokes are final, it's difficult to attain a harmonious effect. To paint the horizon, however, wait for the previous layers of paint to fully dry.

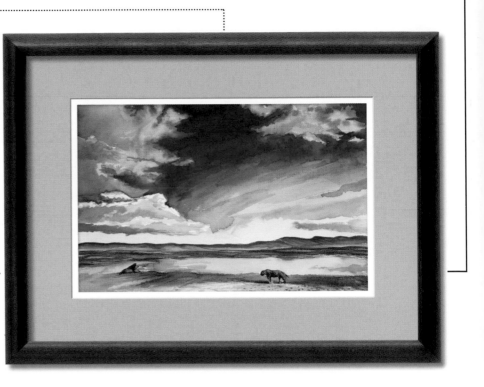

Correcting colors while the pigment is wet

It is easier to touch-up colors over wet pigment than it is to do it over dry. Painting over dry pigment is always noticeable. To recover whites from a dry colored area, keep adding water to the tone until it lightens, and absorb the excess moisture with a dry brush. Again, to create the whites on wet pigment is easy: apply a dry brush on the wet color to remove the paint. The more times you pass the brush over the paper, the whiter the tone becomes.

Note here how the blue color is made lighter by "cleaning" the blue with a dry brush.

Liquid watercolors

The work of the painter is made easier by the use of liquid watercolors to fill in backgrounds, since the color is already diluted.

Liquid watercolors are sold in a large variety of container shapes and sizes, and in a wide selection of colors. The fact that they are liquid doesn't imply these colors are not intense. The quality of the pigment is important, as is the strength and purity of the color. They can be diluted with water if you want a lighter tone. Generally, liquid watercolors are used for professional techniques such as cartography (map art), rather than for traditional watercolor painting.

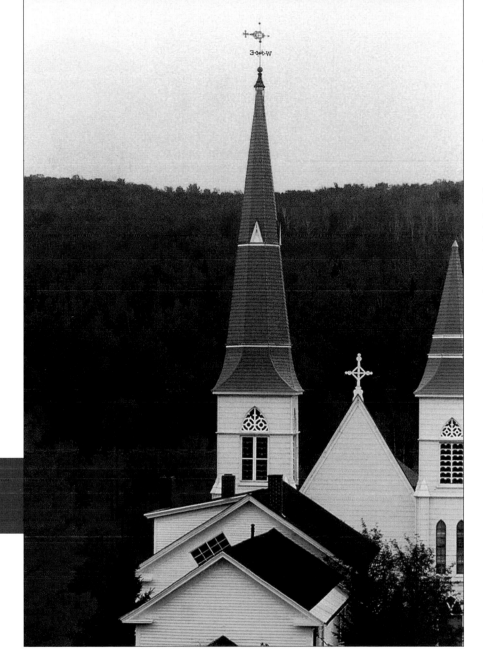

A church in the woods

Landscape is the king of painting themes. The possibilities are as infinite as nature, so there is always a different motive to paint.

Brushes

Thin round-tip brush

Medium round-tip brush

Thick round-tip brush

Narrow flat-tip brush

Palette colors

Lemon Yellow	Permanent Crimson	Hooker's Green
Cadmium Yellow	Cerulean Blue	Sap Green
Cadmium Orange	Cobalt Blue	Sepia
Yellow Ochre	Permanent Violet	Burnt Sienna

An scene filled with contrasts

The contrasts found most frequently in painting are those referenced to chromatic aspects, that is, between light and dark, or cool and warm. However, there is another series of contrasts that are a part of the drawing itself. This scene presents a contrast between the vague forms of the trees in the woods, and the structured walls of the church. This requires two different styles in the same painting. While the trees don't need to be solidified and defined, the buildings demand a very precise treatment. The shapes of the trees can be portrayed either by loose brushstrokes, or in a structured way by separating the tones to simplify the work.

The foundation of the watercolor

Regardless of the technique chosen to represent a specific theme, the first step is to know the medium you work with and its characteristics. Watercolor is the most spontaneous of brush techniques. It is ideal to depict landscapes, skies, and natural forms that don't require a rigid, formal order. It is important to draw a sketch with pencil before applying the color — after applying the color it is nearly impossible to work backwards. Wait for the background colors to dry, before starting work on the structured forms.

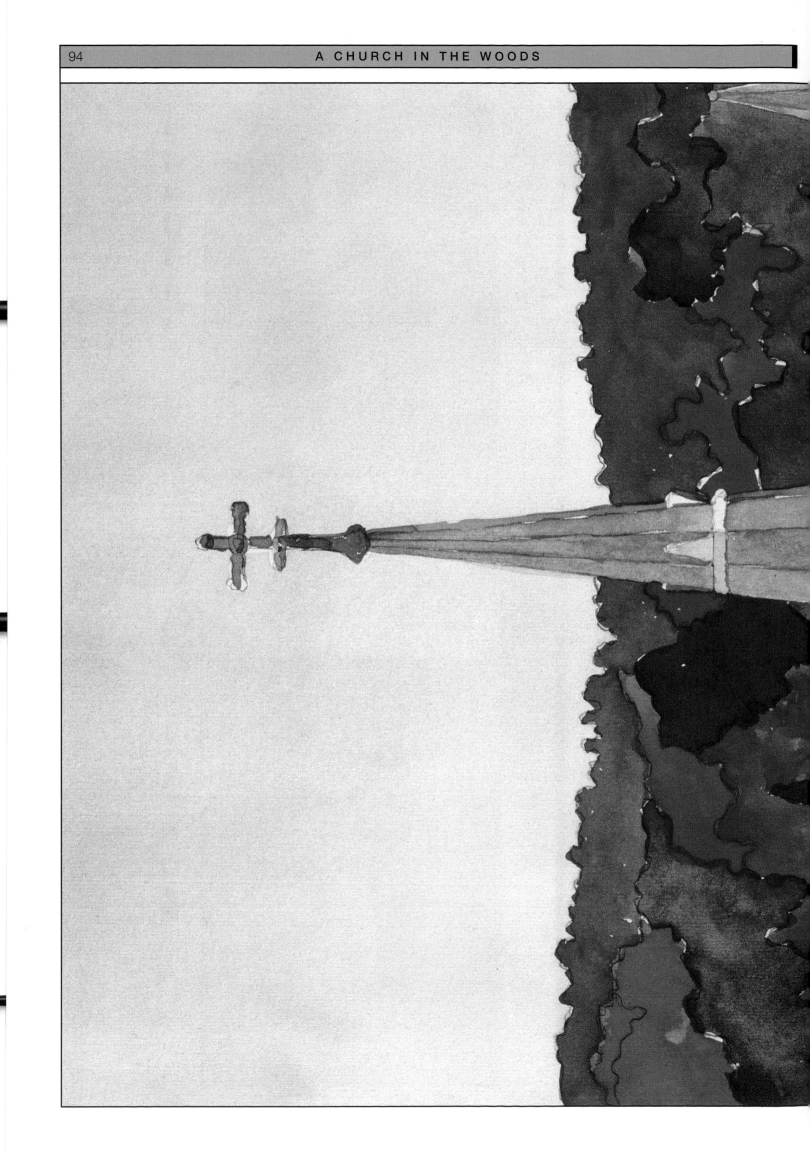

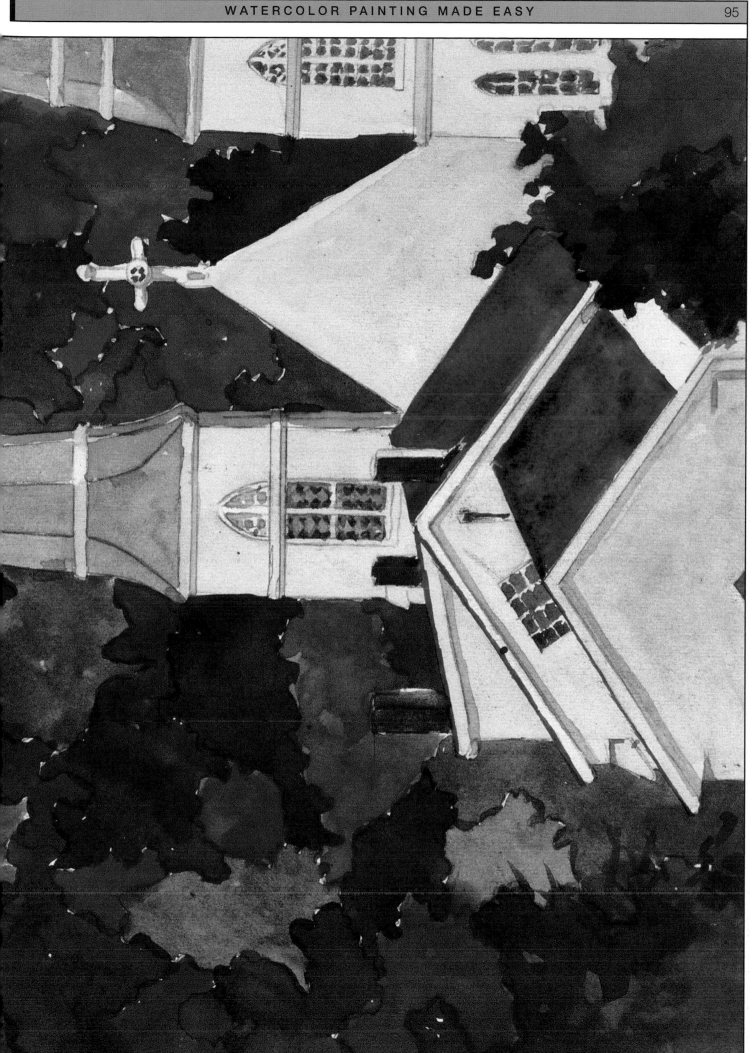

Suggestion for framing

It's easy to combine this painting with any frame, since it has many values and colors. Choose a frame in a dark blue tone that reinforces the tones of the church. Recommend a dark, thick, rounded frame that establishes the contrast with the drawing and balances the complex effect of the scene's woods. Choose a simple matting to complement the general pictorial appearance. The tone of the matting is gray, in concert with the general tone of the church.

ADVICE

If you are having difficulties deciding on the materials for framing, rely on the recommendation of a frame shop. As framing costs can run the gamut, set a budget to guide the framer.

Reserving areas with masking fluid

Liquid masking fluid should be applied with a conventional brush. Wash the brush with solvent afterwards, otherwise this substance will harden.

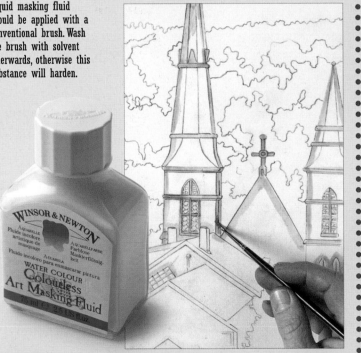

Liquid masking fluid is a creamy solution composed of latex and ammonia. When applied on paper, an impermeable layer is created, protecting the area from the pigment. This allows you to reserve areas on white paper, achieve an impression of shine, or establish limits between pigments. To apply the masking fluid, use a conventional brush and trace the area as if you were applying color. Make sure that the masking film has dried before applying pigments. After applying the color, and once it is dry, the masking fluid is easily removed with a piece of cloth.

Straight lines

It is more difficult to trace a straight line with a brush than it is with a pencil or other rigid tools. As far as brush techniques are concerned, the degree of difficulty depends on the pigment's density. Watercolor, being fluid and liquid, makes tracing easier than when using oil or acrylic pigments, which are denser. To trace the lines, use a ruler or do it freehand. In using a ruler, be careful in gliding the brush next to the ruler. With freehand, trace the line in one stroke so that continuity is maintained.

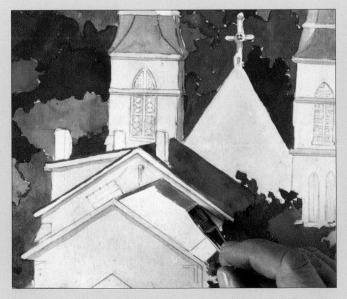

When the straight shapes are not too long, trust your freehand skills. Frequently, flat brushes are the best option for this purpose.

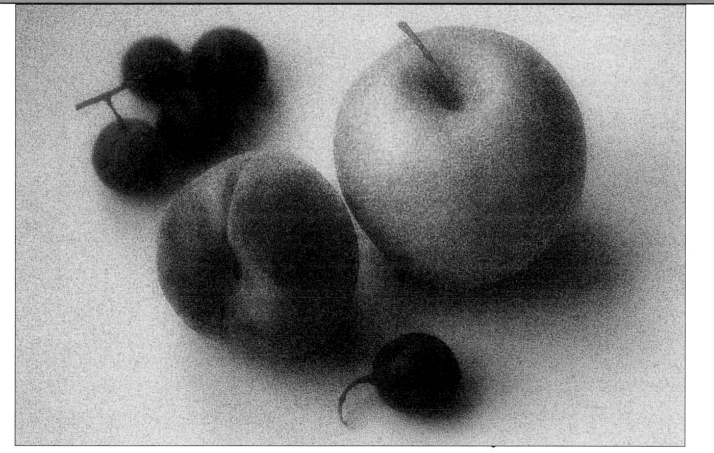

Simple still life with fruit

Arranging a simple still life with household objects gives you the opportunity to experience and appreciate shapes and colors that are different than nature scenes.

Opacity and transparency

Although watercolor is essentially a transparent medium, you can obtain textures and opaque tones by applying the right treatment to the pigment. For example, in dealing with dark and strong tones, increase the amount of pigment to attain an opaque tone. Dark colors and intensely colored objects require a very saturated solution. It is difficult to obtain transparent tones once a dark, saturated color is applied, and it is impossible to work over black. For the light to mid-tone colors, a transparent tone can be maintained by applying lighter tones over them. Very light colors require small amounts of pigment and a lot of water. You can obtain chromatic variations by adding layers of different tones.

Simple forms

Simple forms help us to focus on the different tonal values, as well as on the identification of colors and nuance, because you are not concerned with the complexity of the drawing. In this exercise, all the shapes are spherical. Look for gradations that will create mass and shape to the fruit. In dealing with round shapes, the gradation should follow a circular direction. As for the color, fruit of one simple tone should be painted by applying progressively darker tones over a basic light color in order to represent the shadows. In fruit with more than one tone, combine the application of darker tones to each basic color in a harmonious manner.

Brushes

Thin round-tip brush

Medium round-tip brush

Wide flat-tip brush

Palette colors

Cadmium Orange	Cobalt Blue	Sepia
Yellow Ochre	Ultramarine Blue	Ivory Black
Cadmium Red	Permanent Violet	
Permanent Crimson	Hooker's Green	

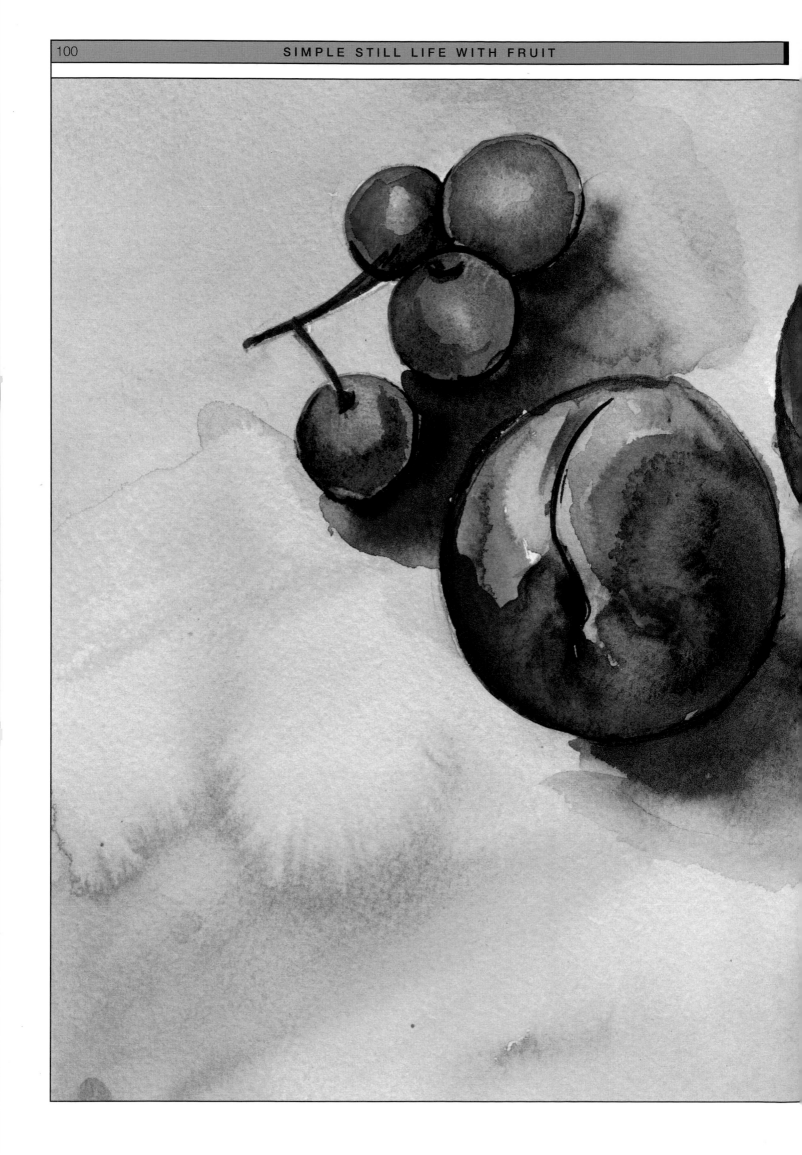

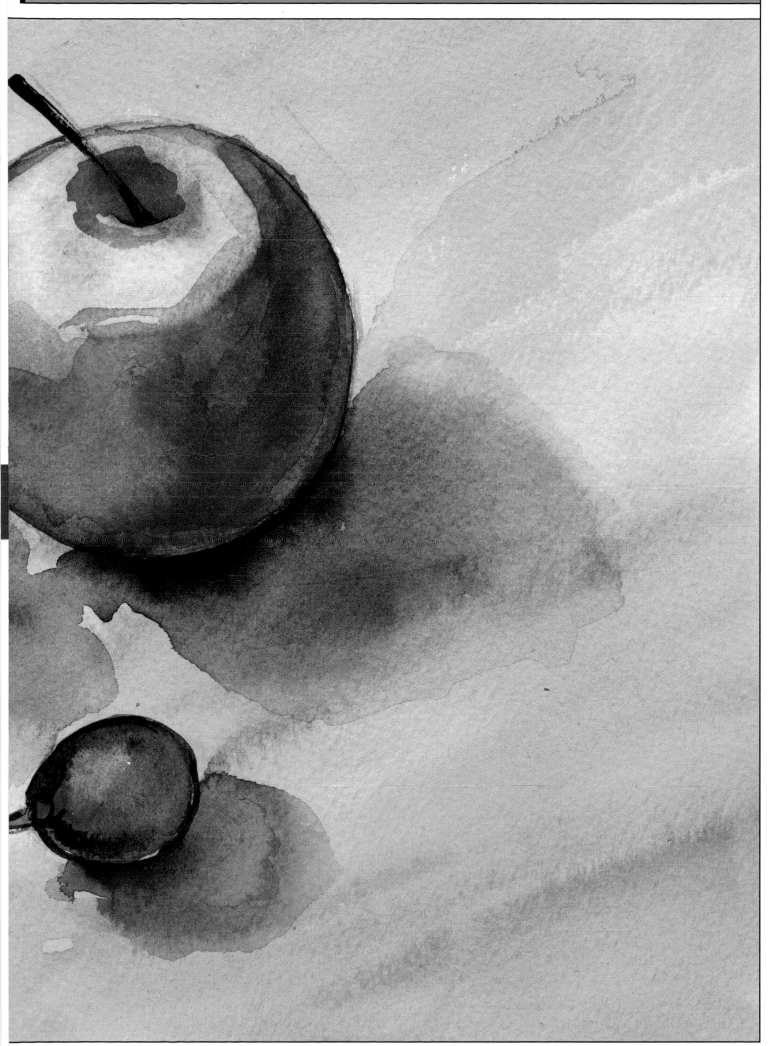

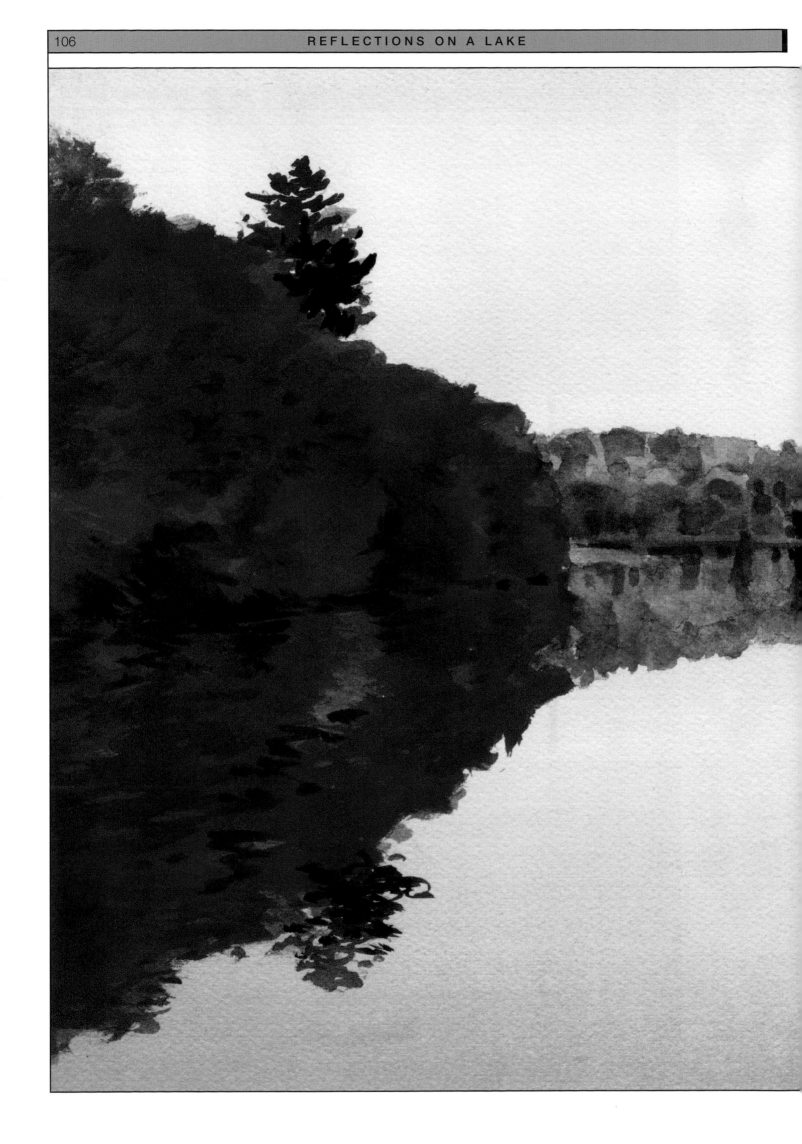

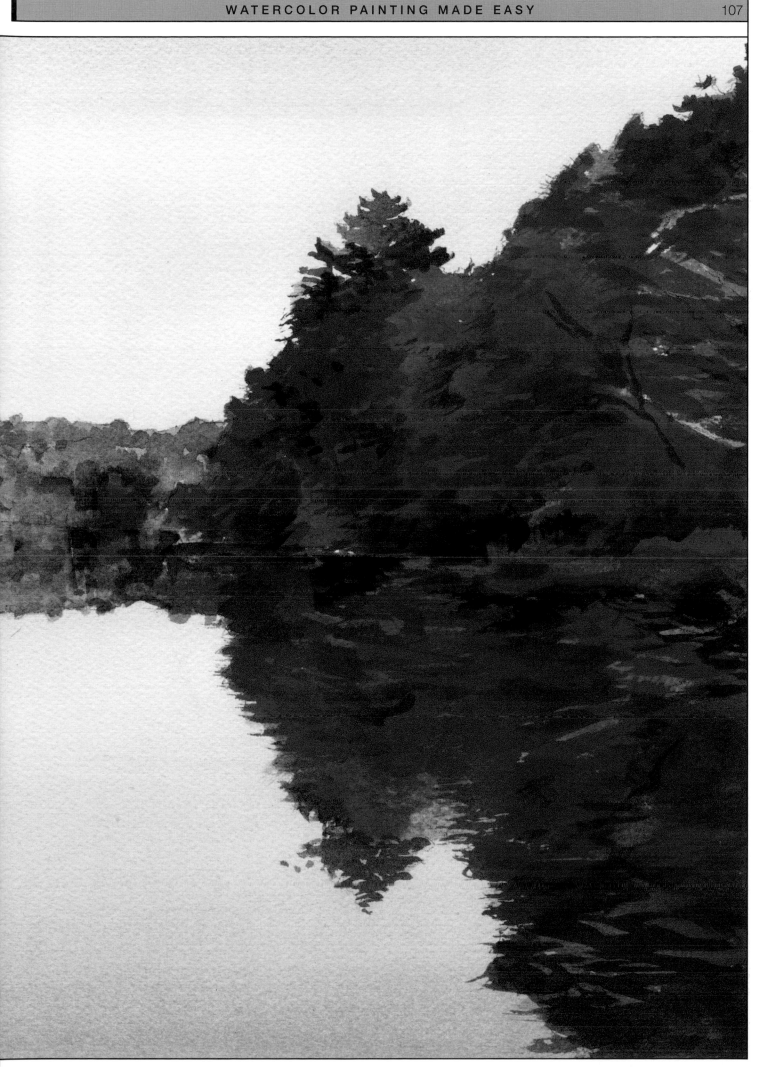

Suggestion for framing

To frame this painting, look to the warm and lively tones of the foliage. A wide matt will enhance the space of the image, projecting its margins rather than limiting them. A thin frame in a warm color will reinforce the values of the painting without being intrusive. A reddish tone wood frame is ideal to highlight the composition.

ADVICE

The color mixture used to paint the base of the painting should not be as intense as the rest of its tones. Therefore, the cobalt blue and sienna used here are very diluted to help create the impression of distance.

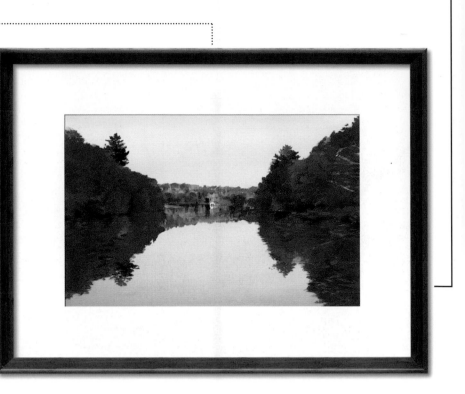

Special papers

Watercolor papers, regardless of their quality, have a percentage of cotton in their composition in order to absorb the water and to adhere the color to their surface. Ordinary papers are composed of cellulose and a synthetic finish, and cannot provide the same function and result as professional grade paper. The process known as "stiffening" consists of an application of a layer of glue that retains the pigment on the surface, preventing it from penetrating more deeply and creating wrinkles. When a paper is not treated this way, its only use is for abstract work or collage. There are also glossy papers, which are mostly used by graphic designers. Their surface is totally smooth and repels moisture. Since they do not retain water, they dry very fast, which makes the brushstrokes very noticeable. These papers are not recommended for watercolor painting.

On glossy paper the pigment does not get absorbed. Conversely, on the cotton paper on the right, you can see how the application is absorbed by the paper.

Creating textures with the sponge

The use of the sponge is not recommended for works that require precision or controlled representations, although it can be useful for other situations. Apart from its use for flat and smooth backgrounds, as well as for washes, a sponge can be used to create textures and suggest shapes. Its irregular texture is ideal for creating natural effects in foliage. The application of the wet pigment with a sponge creates irregular, small dots that imitate the appearance of leaves in the distance. If you combine the application of different colors with the same technique, an attractive multicolored effect is created.

You can see here how the artist uses the sponge to create the effect of colored leaves in the distance.

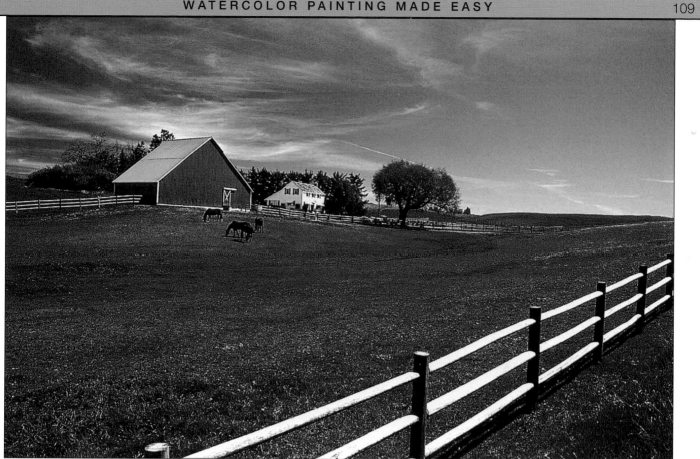

Country landscape

Countryside scenes are very common in art history. Many artists who have been attracted to the simplicity of serene and welcoming rural scenes have represented them in their work.

The plains

The open plains, where the sky and the earth can be clearly contemplated, present a special fascination in nature. In these landscapes, the horizontal line acquires a protagonist role, and all the forms and shapes in the landscape, like trees or houses, have to be carefully composed to avoid a break in the desired horizontal pattern. Here, the horizon is the line of reference, and the rest of elements, like the fence in the foreground, are positioned diagonally to reinforce the sense of distance in the background. Plains have an apparent simplicity that can also be deceiving. They are not exclusively smooth planes that unite in the horizon, rather they are different elements which have to be treated with a progressive intensity as they approach the desired viewpoint.

The art of country landscape

Landscapes in general have the ideal qualities in which you can express your emotions through nature. The countryside is usually quiet, providing a mood of peace and tranquility in which to paint, in contrast with the lively environment of an urban setting. The great landscape painters of the 19th century captured the essence of light and color directly from nature. However, light changes with the movement of the sun, and you need to prepare for this fluid condition. A camera is a great help in landscape painting, since you can capture a moment in time with it. Nevertheless, nuance is lost in the process, as our vision is capable of gathering more details of light and color.

Brushes

Thin round-tip brush

Medium round-tip brush

Thick round-tip brush

Wide flat-tip brush

Palette colors

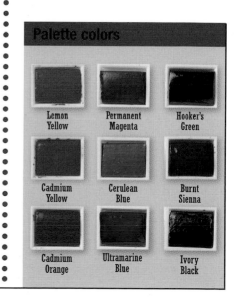

Lemon Yellow	Permanent Magenta	Hooker's Green
Cadmium Yellow	Cerulean Blue	Burnt Sienna
Cadmium Orange	Ultramarine Blue	Ivory Black

Painting the sky

1

Color the sky with a cool blue, a mixture of cerulean and ultramarine blue. Since the area is wide, apply the color with a thick brush. Because you don't want a uniform color, distribute the color in shapes that suggest clouds.

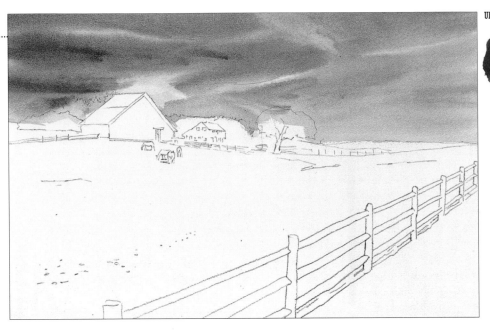

Ultramarine Blue Cerulean Blue

Adding the green tones

2

Color part of the distant area and the plain with a base of green. In the background, use a thin brush to work on the trees, combining ultramarine and Hooker's green to gain dark tones. For the plain, paint broadly using a thick brush in a color resulting from mixing lemon yellow and Hooker's green.

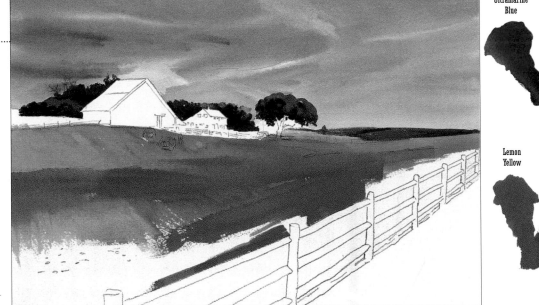

Ultramarine Blue Hooker's Green

Lemon Yellow Hooker's Green

Finishing the grass

3

After carefully reserving the area of the fence, using a ruler as needed, paint the grass in the foreground. In some areas put more yellow in the mixture to give more warmth, and in others accentuate the green. Once the color is dry, apply a very light transparent lilac tone, a mixture of magenta and ultramarine blue, resulting in tertiary tonalities.

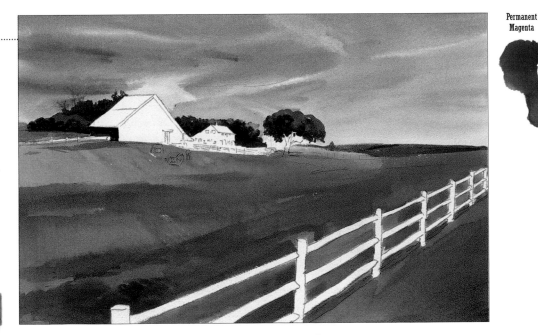

Permanent Magenta Ultramarine Blue

Permanent
Magenta

Burnt
Sienna Ultramarine
Blue

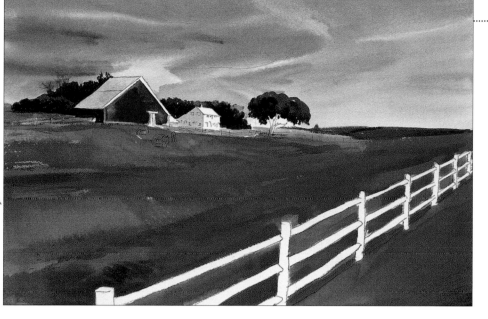

Painting the houses

4

Add details to the colors in the distance, using a thin brush that allows you to treat the forms in a precise manner. Use a very saturated magenta tone for the walls of the barn, and a more diluted tone for its roof. For the small house, use a mixture of sienna and ultramarine blue, applying different proportions of pigments for the warm-toned roof and the cooler wall.

Ivory
Black

Ivory Permanent
Black Magenta

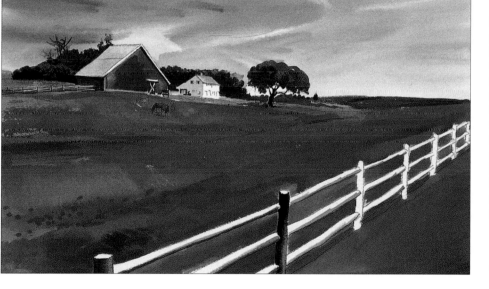

Using brown colors

5

Now, color the fence in the foreground, paying particular attention to its different sides: the brightest ones are white, while the opposite are black. On the doors of the houses, as well as the animals in the distance, apply a mix of black and magenta, resulting in a brown tone. For both situations, use a thin brush, appropriate for straight lines and small details.

Cadmium
Orange

Cadmium
Yellow

Lemon
Yellow

Hooker's
Green Permanent
Magenta

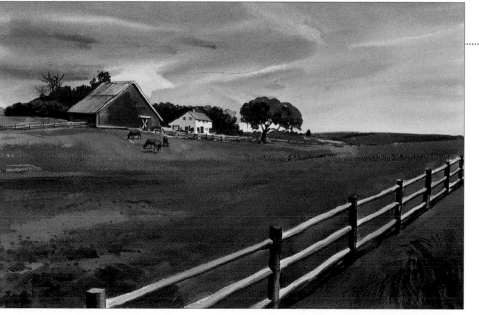

Completing the painting

6

For completion, use a medium brush to create light transparent layers with yellow and orange over the grass, resulting in richer tones of green. Using Hooker's green and magenta, define the grooves and the bushes in the foreground. Using a thin brush, apply the last touches to the fence and the animals in the distance.

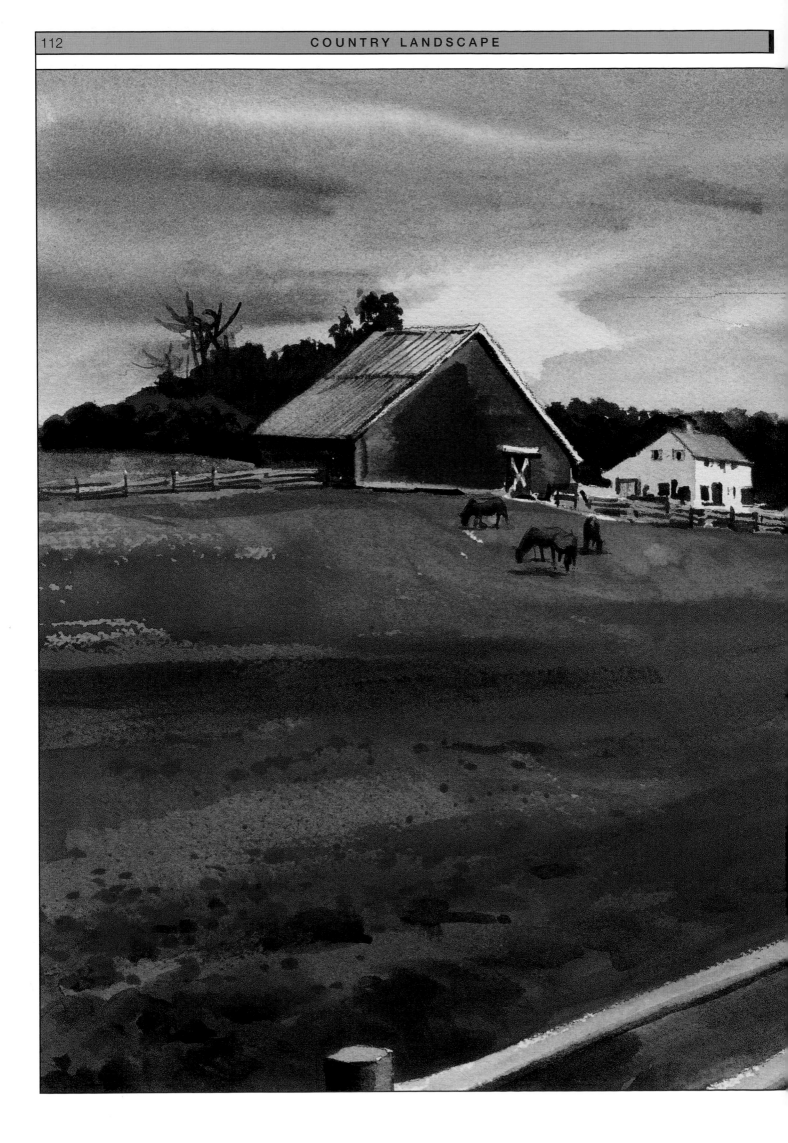

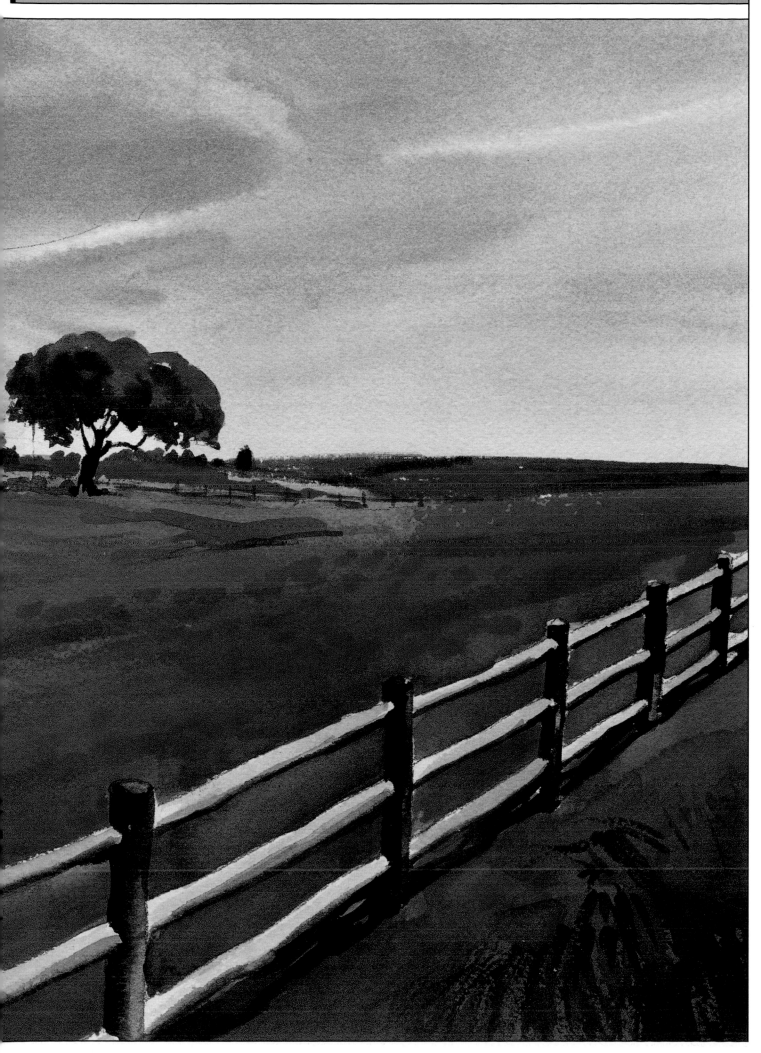

Suggestion for framing

To frame this painting use a chromatic criterion to enhance colors in the painting. Choose double matting — gray for the outer matt and white for the inside matt to brighten the composition and pick up the light colors in the fence. The frame is a dark bluish tone that reinforces the contrasts in the painting and combines with the tones of the sky. As a whole, choose cool tones, which are in harmony with the wide spaces in the painting and will enhance, by contrast, the few warmer tones in the painting.

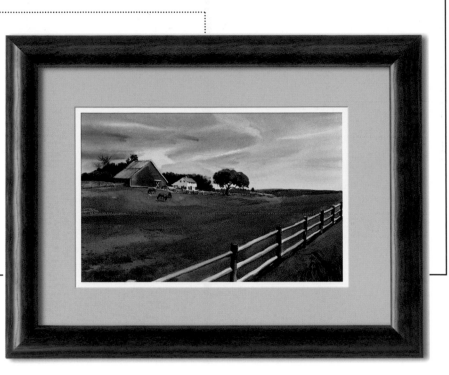

ADVICE

The expansive sweep of color in the painting requires a large amount of pigment. It is common for beginners to use too much water and not enough pigment, thus diminishing the color's intensity. Don't be afraid to use a lot of pigment, since the colors tend to become clearer as they dry. If there is not enough pigment, the result can be too pale.

Support boards for watercolor

Ideal support boards for stretching paper are particle board, plywood or Masonite around 1/4 inch thick.

Support boards are used to attach pieces of paper to them, and as a smooth and stable support surface. Use them with dry paper, or to help smooth the stretching of wet paper. The board must be sturdy so that it does not bend with the tension of the paper as it dries. There are different types of boards; ones made of plastic are very light and thin, ideal to transport, but not suitable for stretching paper. For stretching purposes, use wood boards.

Using a ruler to reserve straight areas

Using a ruler to delineate straight lines with the brush is an important aid. Apply your brush with a light touch following the edge of the ruler. You can also use the ruler to make wider reserves of white by placing it flat on the paper while painting around it. The silhouette of the ruler becomes the reserved area. You can also use a piece of cardboard with straight edges.

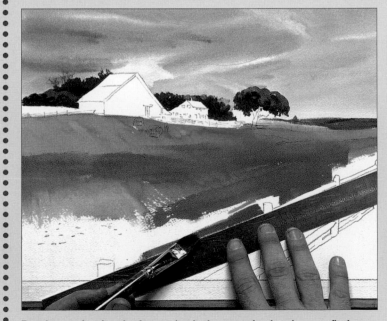

To make sure that the color does not invade the area under the ruler, press firmly on the ruler against the paper, sealing off any open space between the ruler and the paper.

Blending the sea and sky

This theme of contrasting mediums offers interesting harmonies to explore and calls for a studied approach to a fluid subject.

Brushes

Narrow flat-tip brush

Medium flat-tip brush

Wide flat-tip brush

Fluid and transparent subjects

One of the most important challenges for a painter is the observation of light and reflections in any visual situation. When studying water, you are confronted with a great variety of forms and reflections that it acquires as external elements around it change. Water is a totally transparent medium, thus it does not have a color of its own; it depends on the chromatic conditions that are reflected on it. As a result of this constantly moving environment, it calls for close study and use of the artist's intuitive sense. As a fluid and changing subject, water can present a smooth and calm surface, or display fury with powerful waves. It's very helpful to study these ever changing qualities in terms of pictorial representation.

Daylight

Painting seascapes offers the artist many opportunities to explore harmonies: the changing light of seasons; the different light throughout the day; rain, snow, fog, etc. Each of these conditions provides the painter with a great variety of chromatic combinations. Warm tones are usually associated with strong sun light, or with large expanses of sand or earth. Cool tones are associated with winter or water scenes, as well as with rocks and the shoreline. Rainy and cloudy weather calls for tertiary or neutral colors. Depending on the hour of the day, you also find different colors. Sunrise and sunset offer delicate combinations of cool and warm tones. The sunlit hours of the day, in contrast, present very intense colors, with strong and well-defined shadows.

Palette colors

Lemon Yellow Cerulean Blue Sap Green

Cadmium Orange Ultramarine Blue Burnt Sienna

Permanent Magenta Prussian Blue

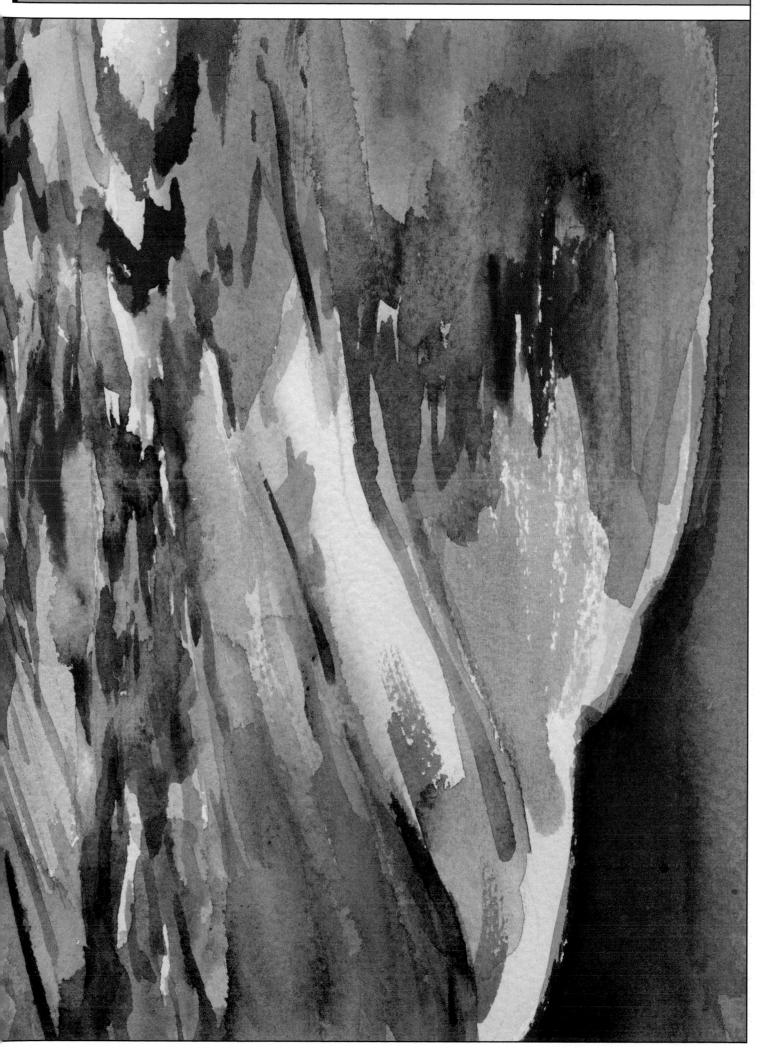

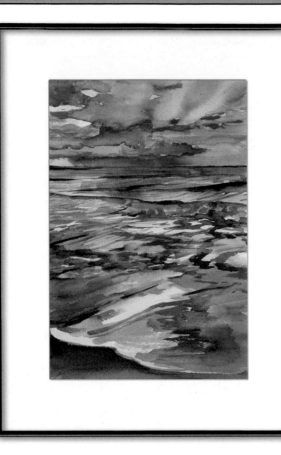

Suggestion for framing

This painting, defined by a great variety of light reflections and colors, requires a simple frame. The matting is white and wide, to give more space to the landscape. As for the frame, choose one in a dark brown tone, in harmony with the sand and some of the painting's reflections. The frame itself should be thin with the emphasis on the matting.

ADVICE

When painting with complementary colors, try to use them as pure as possible. Always use a clean brush, or you can use two different brushes, one for the cool tones, and the other for warm ones.

The impact of complementary colors

Complementary colors, when placed next to each other, do not diminish the intensity of each other's tone, rather it's emphasized by contrast. All colors have a complementary color. When mixing primary colors (red, yellow, and blue) you obtain secondary colors: green (from blue and yellow), orange (from red and yellow), and violet (from red and blue). One color is complementary to another when it has the opposite primary colors in its composition.

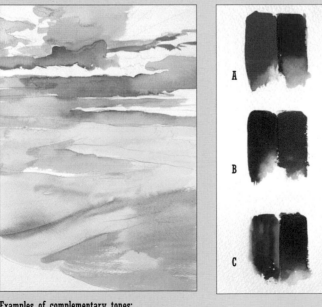

Examples of complementary tones:
A- Cadmium Yellow (primary), and Ultramarine Blue (secondary).
B- Crimson (primary), and Medium Green (secondary).
C- Cerulean Blue (primary), and Cadmium Red (secondary).

Special brushes

Some brushes cannot be simply classified as flat or round. The shape of the brush is sometimes very special to complement a specific type of work. Fan-shaped brushes usually have a flat tip that gives the brush an open shape. They are used to obtain a uniform chromatic transition on an already painted surface. Their use with pure pigment has an effect similar to those of a dry brush, which is sometimes appropriate for creating certain color fusions. Japanese brushes have very long hair, which allows for very thin strokes if the tip is used, or when used sidewise for wide water-washes.

Japanese brushes

Fan-shaped brushes

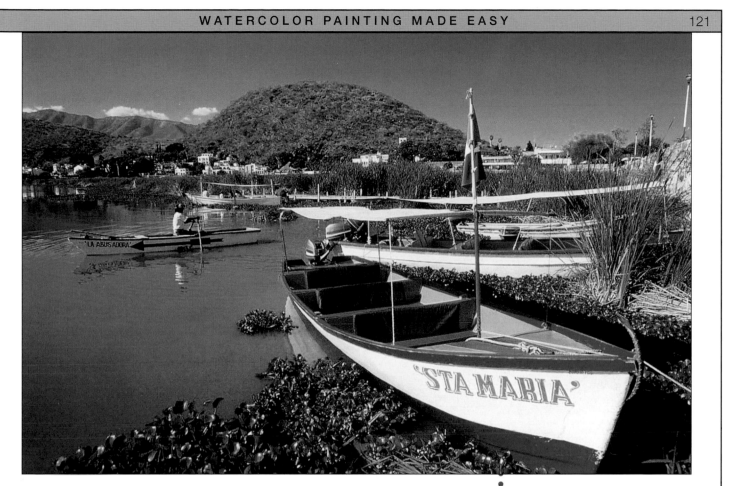

Traditional coastal scene

Boats are often a common theme in a coastal scene, and they give the opportunity to explore a variety of colors that sometimes are not found in portraying the sea.

A picturesque coastal setting

This beautiful scene combines two popular themes — the landscape and seascape. However, when fishing boats are added, or other set elements, the view encompasses a human dimension, as it reflects the lives and customs of people. Thus, there is more in this scene than just a vision of nature's harmony. The joining of land and sea is compounded with elements that narrate a story or a situation determined by the presence of human beings. While this coastal landscape includes fishermen and boats on the shore, the beauty of the water remains a focal point, even if the power of the ocean is not captured. The artistic composition here captures a way of life of people who live by the sea, and the boats they navigate.

The importance of composition

Every work of art has a basic element that sustains the painting's balance. That basic element is the composition, which makes the result attractive to the eye, with all the elements in the painting organized within the space. The challenge consists in finding the best point of view to represent the scene. Composition is a very important factor, both for simple works, such as a still life, and for a complex scene shown here. The boat in the foreground establishes the main element, in relation to which the other elements are arranged — from those closest to the eye in the foreground, to the ones in the distance. The variety of textures and objects offer new challenges, and you should evaluate each element thoughtfully.

Brushes

Thin round-tip brush

Medium round-tip brush

Thick round-tip brush

Narrow flat-tip brush

Palette colors

Lemon Yellow	Cadmium Red	Hooker's Green
Cadmium Yellow	Permanent Crimson	Olive Green
Cadmium Orange	Cerulean Blue	Burnt Sienna
Permanent Magenta	Cobalt Blue	Ivory Black

First colors

1

First, color the sky and the water with a mix of cerulean and cobalt blue. In a very diluted manner, apply a uniform color in which the brushstrokes are not noticeable.

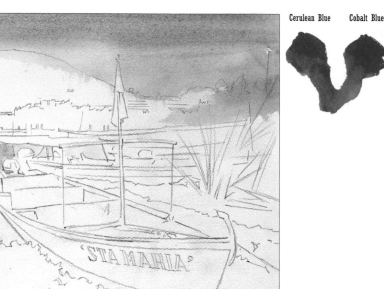

Cerulean Blue Cobalt Blue

Adding the lilac tones

2

Mix different proportions of blue, magenta and black to obtain a variety of lilac tones. The mountain in the distance should present a more violet tone, and the bigger, closer one, should have more magenta to present a warmer and more intense tone. In addition, add this tonality to the lower part of some boats.

Cobalt Blue Permanent Magenta

Ivory Black

The green area in the distance

3

Create different tones of green to color this area using short, vertical brushstrokes. Using a thin brush helps to control the shape and length of the strokes. When applying the color, reserve the area for the houses in white. To obtain the greens, use a mixture of Hooker's and olive green, as well as cobalt blue.

Hooker's Green Cobalt Blue

Olive Green

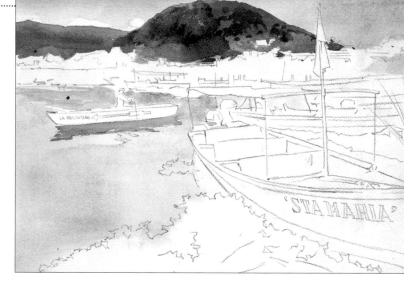

Permanent
Magenta

Ivory
Black

Lemon
Yellow

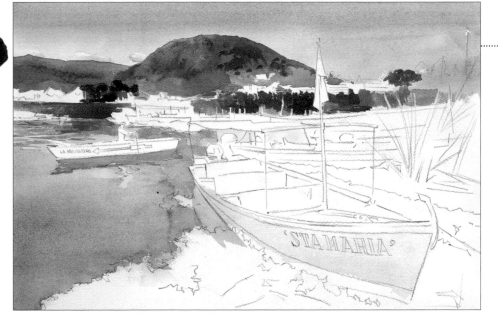

Adding tones to the sea

4

Apply a very light transparent mixture of magenta and black to the blue base of the water surface. This effect creates a violet tone over the whole area. In addition, apply some brushstrokes in the same tone to the distant area, indicating the movement of the water. Apply a very light and transparent yellow tone to the boat in the foreground.

Hooker's
Green

Cerulean
Blue

Cerulean Blue

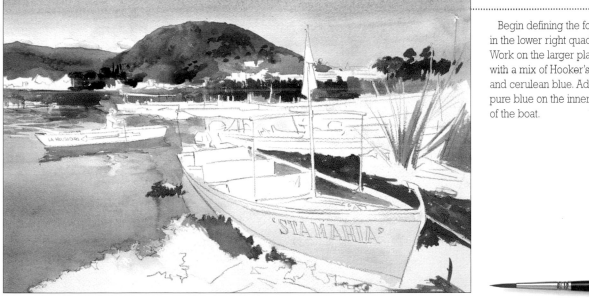

Adding more green

5

Begin defining the foliage in the lower right quadrant. Work on the larger plants with a mix of Hooker's green and cerulean blue. Add pure blue on the inner side of the boat.

Cadmium
Yellow

Olive
Green

Cadmium
Red

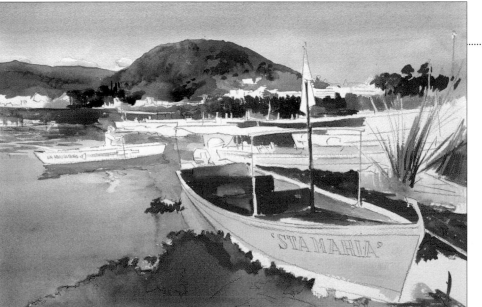

Painting the foreground

6

Use a mixture of yellow and olive green to color the flora in the foreground. Paint the color flat in order to add different texture variations later. Then add yellow and some touches of red to define the base color of the seats in the boat.

Establishing contrasts in the foreground

7

Using a mix of Hooker's green and black, apply darker brushstrokes onto the light green base color. These strokes will imitate leaves and will allow some of the brighter light green beneath to remain visible. Now, add crimson to the boat, and define the flag with cadmium red and Hooker's green.

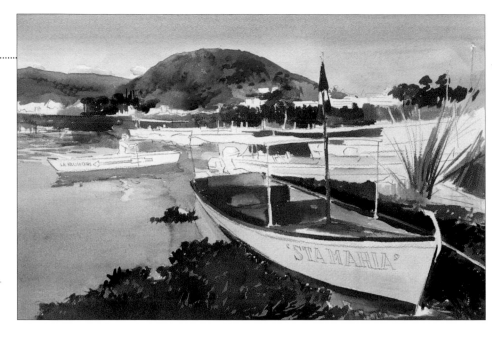

Hooker's Green Ivory Black

Permanent Crimson

Defining the boat

8

Define the inside of the boat by establishing color contrasts and adding details. Using a thick brush, apply a mixture of sienna and blue to darken the boat seats, leaving the crest of the seats in their original light tone. Using a thin brush, apply a mixture of sienna, crimson and black to draw the silhouette of the inner section, as well as the flag and little masts.

Burnt Sienna Cerulean Blue

Permanent Crimson Ivory Black

Burnt Sienna

Small details

9

Further define the front of the boat by adding orange to the yellow base. Use the lilac tone you used before to define the boat with the rower in the distance. Using a mix of crimson, black and burnt sienna, establish the contrast of the boats in the center area.

Cadmium Orange

Hooker's Green

Olive Green

Ivory Black

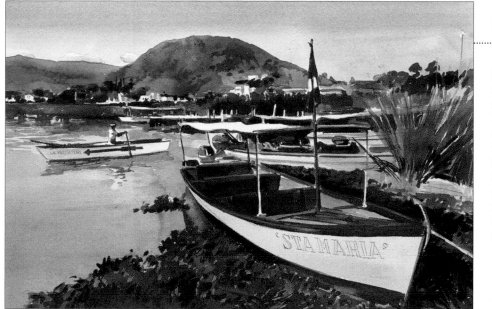

Defining the bushes

10

Now establish contrasts in the bushes on the right, especially the one with straight and vertical leaves. Using a medium brush, first apply an olive tone, and then Hooker's green with thin brushstrokes following the direction of the leaves. Add some detail to the houses, using an orange tone, and define the second boat using black and red.

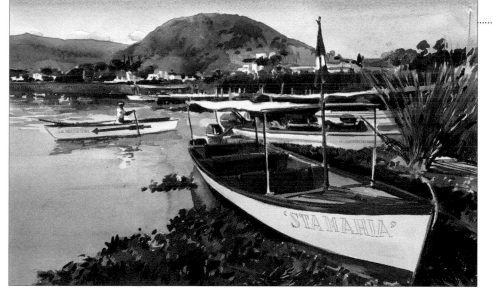

Contrasts in the bushes

11

Doing the same as step 10, except this time use a thin brush that helps to create depth in the bushes. Pure black will create a high contrast on the closest branches.

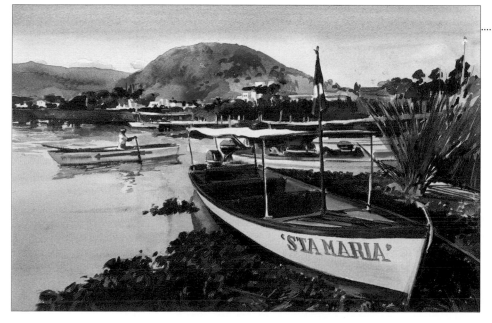

Final step

12

To complete, paint the words on the boat. Use a thin brush and a touch of black to draw each letter. This color should be diluted to appear gray.

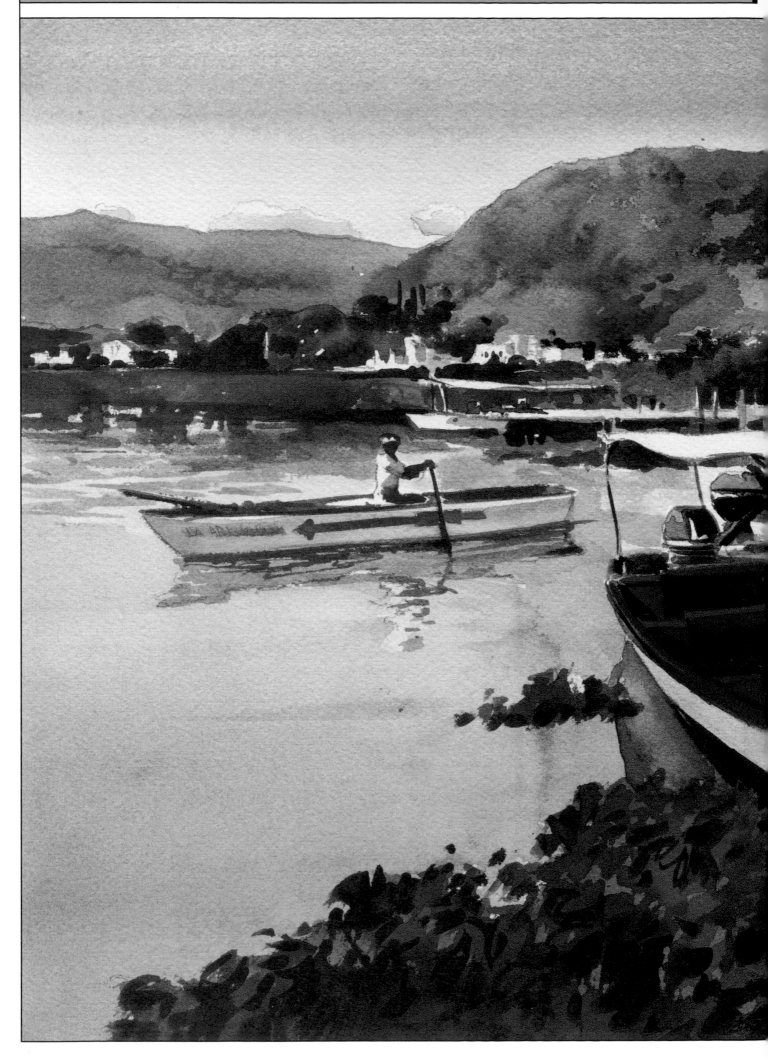

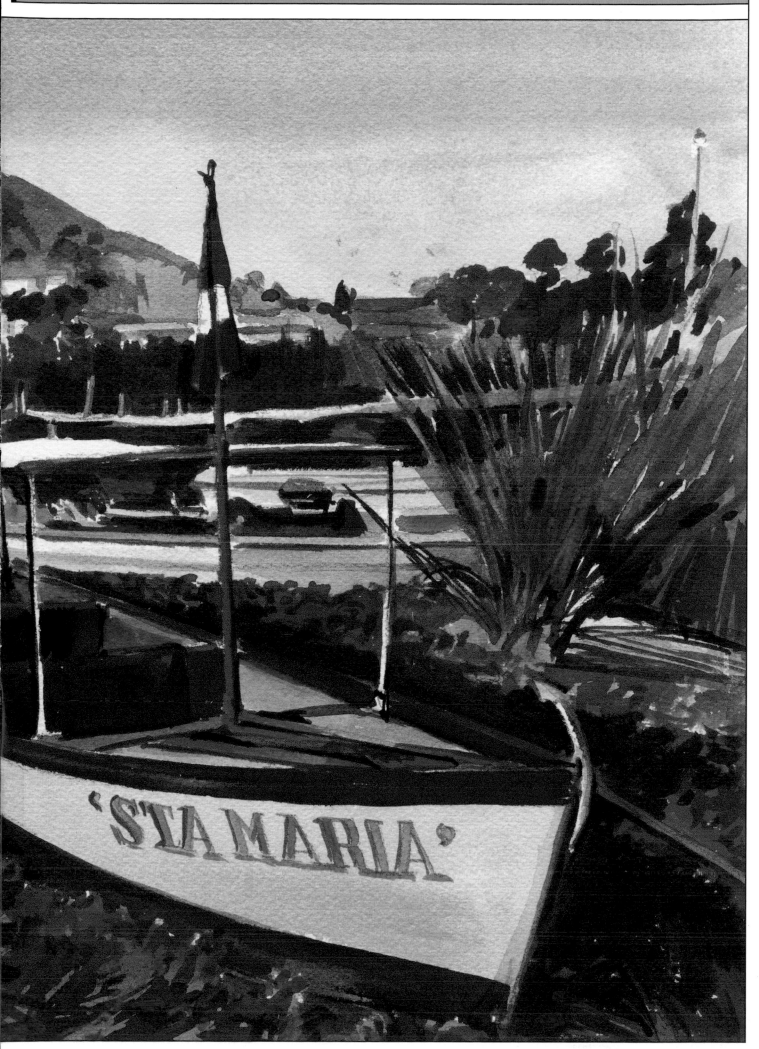

Suggestion for framing

This painting calls for a powerful and complex frame to reinforce the traditional aspects of the work. Use double matting: an inner one in white and an outer one in a cream tone. Given that the painting has many contrasting colors, choosing a general cream tone establishes an overall balance, especially with the sky and the sea. A classical frame of a dark brown tone and antiqued wood gives a traditional look and complements the painting.

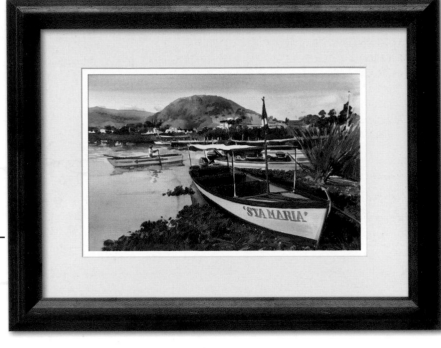

ADVICE

Organization is crucial when the challenge is to complete a work of complex colors and elements. It's fundamental to work from light to dark, from background to foreground, and to establish first the large areas of color, leaving the details for the end.

The base drawing

The basis of any painting is not just the control of colors, light and shadows. An important consideration, integral in any painting, is the base drawing that depicts the objects, the silhouettes and the proportional sizes of the elements. The drawing begins with options to consider in determining the optimum viewpoint from which to represent the scene. Once this is established, balance the composition and layout all the elements on paper. Composition is based on the balanced distribution of elements within a space. When the outlines and desired details of the objects are completed, painting is basically a matter of following the guides established by the base drawing.

An accurate preliminary drawing is fundamental for both simple and complex paintings. This practice ensures the success of a painting.

Complementary materials

Watercolor painting can include other materials such as felt-tip pens, graphite pencils, and watercolor pencils. These materials combine well with water, and are easier to control on paper than the brush. Conventional colored pencils can be used in combination with the watercolors, reinforcing certain lines and shapes. You can also combine water-based felt-tip pens, emphasizing some of the forms suggested by watercolor, or to create a mixed effect of lines and gradations. Watercolor pencils and water-based felt-tip pens can dissolve with the watercolor pigment itself. This is very convenient when you want to strengthen a certain area of color without revealing that different materials are used.

Using mixed techniques, such as a combination of watercolor washes and brush drawing, result in contemporary and lively compositions.